IMAGES
of America

CAMPBELL SOUP
COMPANY

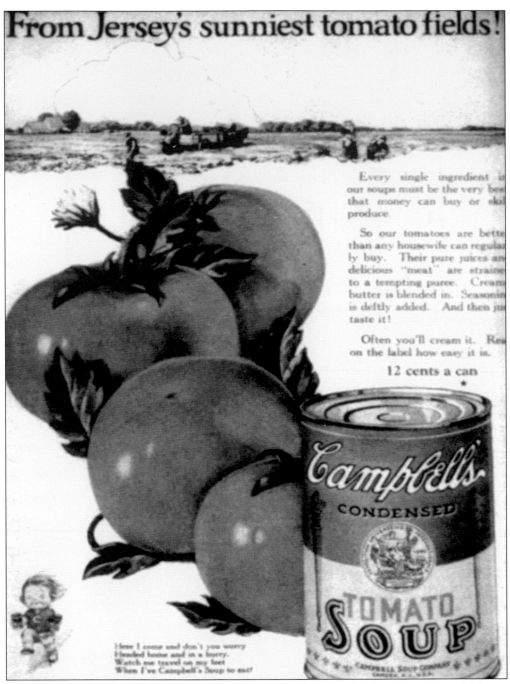

The headline and text of this undated advertisement heralds the Jersey tomato, which was grown for the Campbell Soup Company by farmers in the southern portion of the state, near the Camden manufacturing plant. The farmers who grew for Campbell actually received seeds from the company, including varieties such as Marglobe, Greater Baltimore, Pritchard, JTD (named for Dr. John Thompson Dorrance, who developed the formula for condensed soup in 1897), and Rutgers. The tomatoes, of course, were turned into the company's most popular variety, tomato soup. (Courtesy of Harry Nelson.)

IMAGES
of America

CAMPBELL SOUP
COMPANY

Martha Esposito Shea and Mike Mathis

ARCADIA
PUBLISHING

Published by Arcadia Publishing
Charleston SC, Chicago IL, Portsmouth NH, San Francisco CA

Printed in the United States of America

Library of Congress Catalog Card Number: 2002106356

For all general information contact Arcadia Publishing at:
Telephone 843-853-2070
Fax 843-853-0044
E-mail sales@arcadiapublishing.com
For customer service and orders:
Toll-Free 1-888-313-2665

Visit us on the Internet at www.arcadiapublishing.com

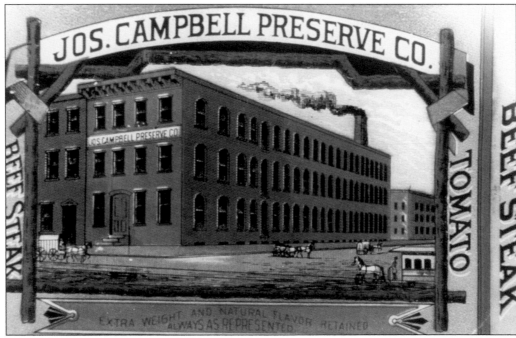

An early advertisement depicts the Camden, New Jersey offices and factory of the Joseph Campbell Preserve Company. The company got its start in 1869, when fruit merchant Joseph Campbell and icebox manufacturer Abraham Anderson formed a business to can tomatoes, jellies, condiments (such as ketchup), mincemeat, and vegetables. Anderson left the company seven years after it was formed.

CONTENTS

ACKNOWLEDGMENTS

The following people were helpful in assisting us with the photographs and the background information for this book: John Faulkner, director of brand communications for the Campbell Soup Company; Jennifer Fulton, archivist for the Campbell Soup Company; Harry Nelson, president of the Campbell Kid Retirees; and Dennis McDonald, staff photographer with the Burlington County Times.

Sources for this book included *America's Favorite Food: The Story of Campbell Soup Company* (1994), by Douglas Collins; the *Burlington County Times;* and www.campbellsoup.com.

Unless otherwise indicated, photographs throughout this book were provided by the Campbell Soup Company.

I want to thank my husband, Michael, for his love, patience, support, and proficiency with scanner and computer. Thanks also to my mother, Harriet Esposito, for her love, support, and continued encouragement. —Martha Esposito Shea.

To Beverly, Melissa, and Michael Jr., thank you for your love and support. —Mike Mathis.

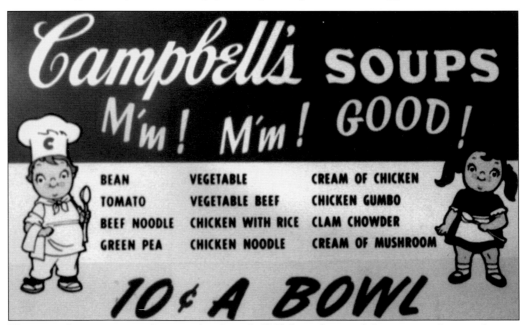

This tin advertising sign features the Campbell Kids and two of the company's most famous slogans: "10 cents a bowl" and "M'm! M'm! Good!" The latter is still used today. (Courtesy of Harry Nelson.)

INTRODUCTION

Just four years after the Civil War ended, two Camden, New Jersey entrepreneurs joined forces to form what later became one of America's best-known and enduring corporate entities—the Campbell Soup Company.

In 1869, fruit merchant Joseph Campbell and icebox manufacturer Abraham Anderson formed the Joseph Campbell Preserve Company to produce canned tomatoes, vegetables, jellies, soups, condiments, and mincemeat.

Nearly 20 years later, in 1897, Dr. John T. Dorrance, a chemist who was the 24-year-old nephew of general manager Arthur Dorrance, joined the company. He agreed to pay for laboratory equipment out of his own pocket and accept a salary of $7.50 per week.

That same year, Dorrance invented condensed soup, a process that eliminated the water in canned soup. The process lowered the costs for packaging, shipping, and storage, enabling the distinctive red-and-white cans of soup to become a staple in most American households when it had previously been a delicacy for the wealthy. The popularity of condensed canned soup prompted the company to add the word *soup* to its name in 1922.

Meanwhile, marketing executives at Campbell Soup used advertising as a tool to help place their product into more homes, a practice that has made the company one of the most prolific advertisers in the United States today.

In 1904, the Campbell Kids were introduced in a series of trolley car advertisements. Around the same time, the first print advertisement appeared in a magazine, advertising 21 varieties of soup that sold for a dime per can.

In the 1930s, Campbell entered into radio sponsorship with its familiar "M'm! M'm! Good!" jingle. The introduction of television into the popular culture in the 1950s furthered the popularity of Campbell soup into American kitchens through such celebrities as Ronald Reagan, Donna Reed, George Burns, Gracie Allen, and Lassie.

By 1962, the Campbell soup can had become such an icon of American life that artist Andy Warhol memorialized it in numerous pieces of his artwork.

Campbell Soup has expanded its culinary empire far beyond canned soup. The company also produces such well-known products as Pepperidge Farm baked goods, Franco-American gravies and pastas, Prego spaghetti sauces, V8 juices, and Godiva chocolates.

Campbell products are available in virtually every country in the world, and the variety of available soups has expanded far beyond tomato, which was introduced in 1897, and cream of mushroom and chicken noodle, which debuted in 1934. Consumers today can purchase Chunky, Home Cookin', Simply Home, and Healthy Request soups.

Regional varieties, such as watercress and duck-gizzard soup in China and cream of chili poblano soup in Mexico, have been introduced to cater to the palates in foreign nations.

Through the following photographs and text, the history of a product that is so familiar to American consumers is brought to life.

12. 7 - 1897

Plum Pudding

204 # Bread Cr. 4
130 " Currants 5½
80 " Suet
90 " Seedless Rais 6
140 " N O Sugar
4 " Nutmeg
6 " Cinnamon 17
50 " Citron 11¼
20 " Sultanna Rais 15
1 Gallons Milk
4 " N O Molasses
2 Quarts Rum
30 Doz Eggs 18
24 oz Bl Carb So 30
3 Salt
6 # Lemon Peel
6 " Orange "
Wheat Flour 18 total

This recipe for plum pudding, handwritten by Joseph Campbell, uses amounts (including two quarts of rum) that indicate it was for the commercial preparation of the delicacy.

One

FROM TOPSOIL
TO TESTING

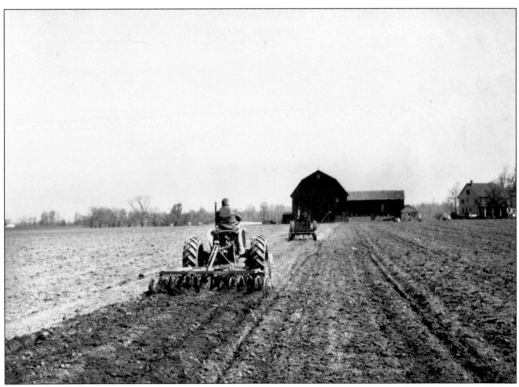

In this 1966 scene at the Stemmer Farm in Rancocas, New Jersey, Charles Moran and Larry Russell apply an herbicide to the crops for a tomato variety trial. The Stemmer acreage was one of many South Jersey farms that grew tomatoes for the Campbell Soup Company.

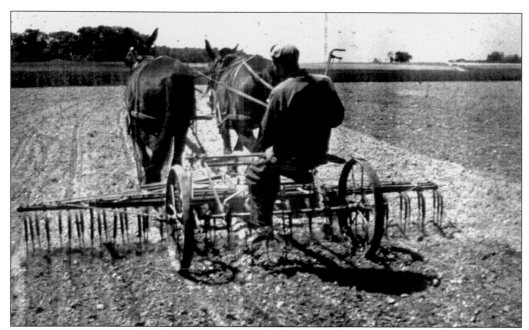

A farmer uses a mule-drawn weeder to prepare the fields for planting at a farm along Branch Pike in Cinnaminson, New Jersey. Where neat rows of tomato plants once grew, a housing development now stands.

In this undated photograph, field hands take a break from picking tomatoes with the help of automated equipment. After the tomatoes were plucked from the plants, they were brought to the Campbell plant almost immediately, since the produce has a very short shelf life.

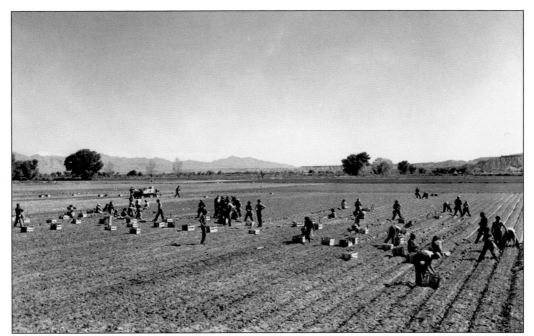

At the Moapa reservation outside Las Vegas, Nevada, members of the Southern Paiute tribe pick radishes in 1940.

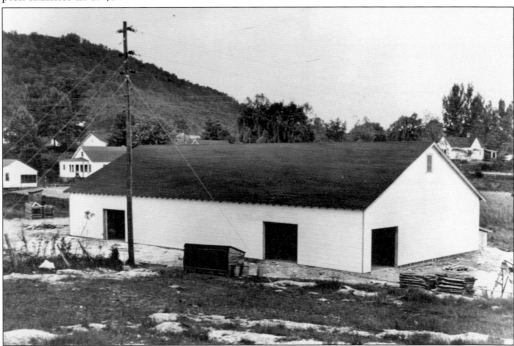

As the company and the public's demand for its products grew, the Joseph Campbell Company began to expand outside of New Jersey. Since the growing season in the Garden State is short, company employee R. Vincent Crine discovered it could be extended if seeds were planted in Georgia in February and the seedlings shipped to New Jersey after all threat of frost was over. This farm in Blairsville, Georgia, is pictured in the early 1920s.

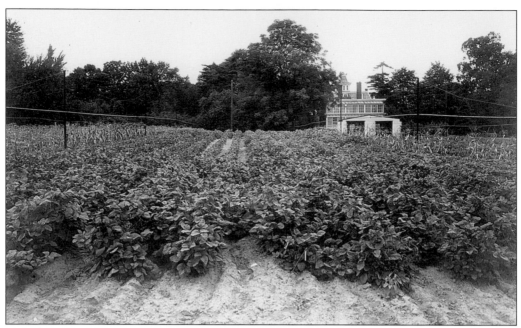

Dr. John T. Dorrance grew tomatoes in the fields surrounding Pioneer Research Laboratory in Cinnaminson, New Jersey. The building itself, seen *c.* 1945–1946, was actually Dorrance's home, where he lived with his wife and five children.

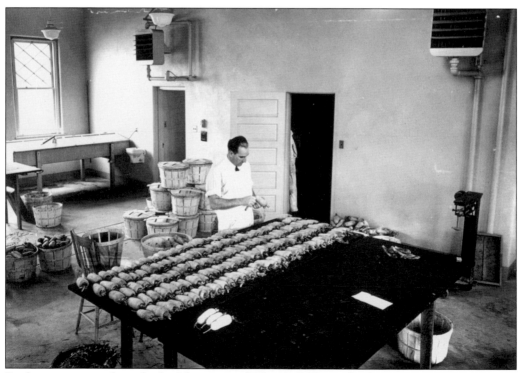

Produce is inspected inside the laboratory, which was built on the former Parry property.

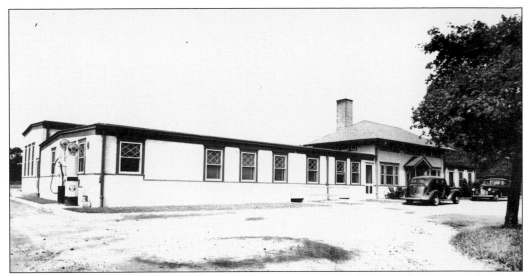

In this exterior view of the building, the home's former grandeur is still apparent from the roofline and entrance on the right, while the addition on the left is evidence of the home's use as an experimental facility.

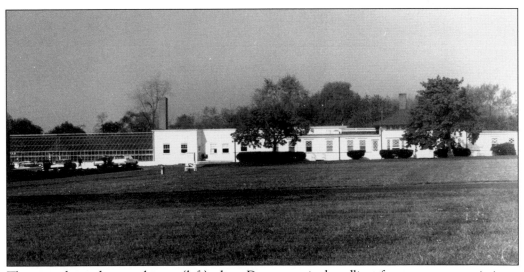

This view shows the greenhouses (left) where Dorrance raised seedlings for new tomato varieties.

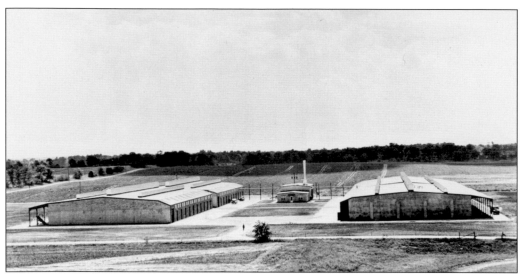

The Prince Crossing Farm in Chicago was obtained by the company in 1945 for mushroom growing. It consisted of 165 acres and was self-contained, with housing and medical facilities for workers. It also had a resident registered nurse and recreational facilities. The first mushrooms were picked at the farm on March 17, 1947. Up until that time, the company had relied on growers in Kennett Square, Pennsylvania (the self-proclaimed mushroom capital of the world), for the vegetables needed for cream of mushroom soup. However, shipping the mushrooms from Pennsylvania to the Campbell plant in Chicago proved to be an expensive proposition, so this farm was used to supply manufacturing efforts there.

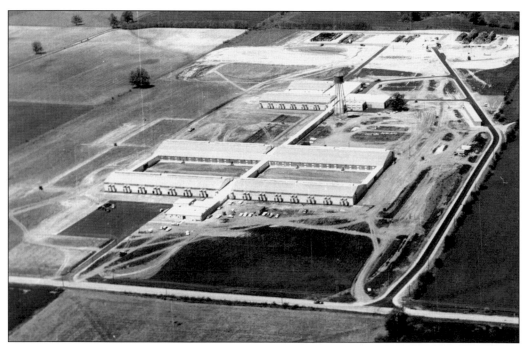

Soon, facilities in other parts of the country—such as this mushroom farm in Brighton, Indiana—helped with regional growing and shipping for the company.

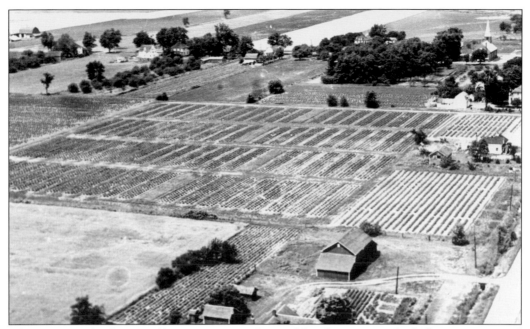

Always in search of new and better varieties of vegetables, the company looked to experimental farms, such as the Riga facility in Michigan, seen in this 1948 photograph.

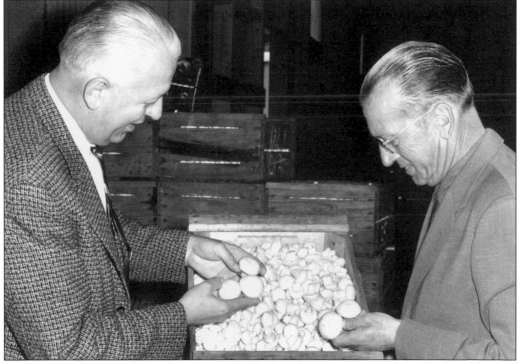

In this 1959 photograph, Carl Swanson (left), the plant manager at the Campbell plant in Sacramento, California, is looking over mushrooms with William E. Chambers, farm manager at Gazos Creek, a mushroom farm that was started to supply the company's West Coast manufacturing facilities.

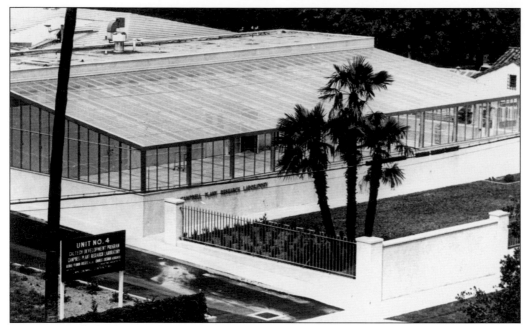

The Campbell plant research laboratory in Sacramento, California, was dedicated to the task of expanding the California Institute of Technology's research into the biology of viruses and the techniques of making plants grow in a wider variety of climates. The Campbell Soup Company gave the university $170,000 toward the laboratory.

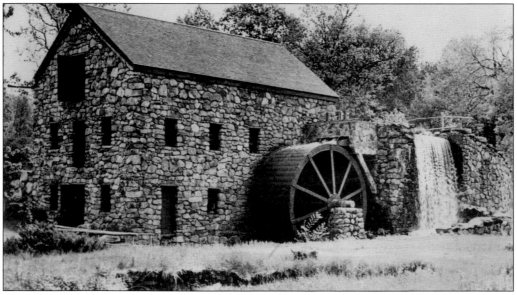

This Sudbury, Massachusetts gristmill ground flour for early Pepperidge Farm bread. Pepperidge Farm was founded by Margaret Rudkin of Fairfield, Connecticut, in 1937 after her nine-year-old son was diagnosed with severe asthma and prescribed a diet rich in vitamin B. When she could not find bread made with stone-ground, whole-wheat flour for him to eat, the housewife decided to begin making her own, turning Pepperidge Farm into a multimillion-dollar company by the time it was purchased by the Campbell Soup Company in 1960. Today, it remains a wholly owned subsidiary of the company.

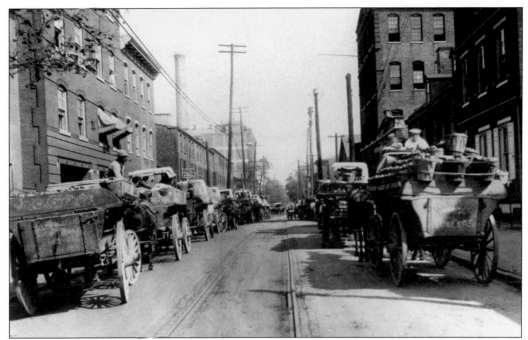

Horse-drawn wagons from area farms wait to get into the Camden plant. Local legend has it that the roads leading to the Campbell facility ran red with the pulp and juice of tomatoes that bounced off the wagons as they rode along the cobblestone streets.

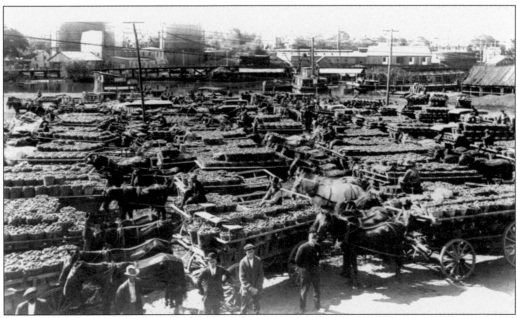

A sea of farmers, wagons, and tomato bushels waits in the courtyard of the plant. The tomatoes needed to be processed soon after harvesting to ensure a good product. The loading dock at the plant opened each day at 5:45 a.m., where inspectors would grade the tomatoes. Those that were good in color and free of decay, mold, or cracks were graded No. 1. Those that were branded No. 2 were not as perfect, and farmers were paid less for them.

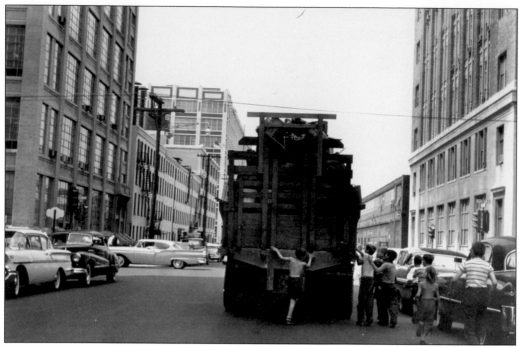

On a hot August day in 1958, neighborhood children run behind a farm truck as it makes its way past RCA in Camden on its route to the Campbell plant.

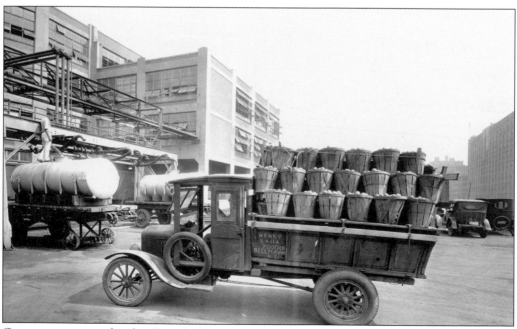

Growing tomatoes for the Campbell Soup Company was the lifeblood of many area farmers. This truck brought produce from nearby Bellmawr to the Camden plant.

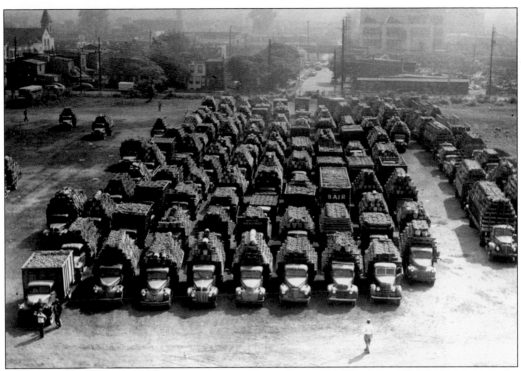

Each truck that came to the plant held between three and four tons of tomatoes grown by farmers under contact to the company.

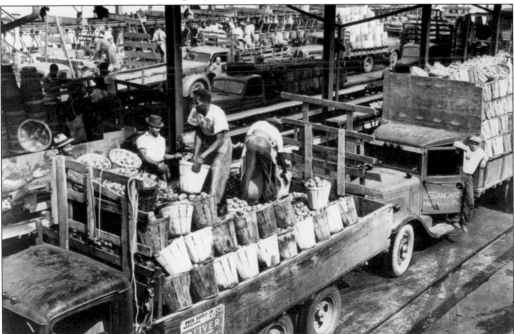

Farm hands help unload bushels of tomatoes. From the loading dock, where the produce was graded, it was washed. It was then put onto a conveyor that took it to inspection stations, where underripe or bad tomatoes were discarded and bruises and other imperfections were carved away.

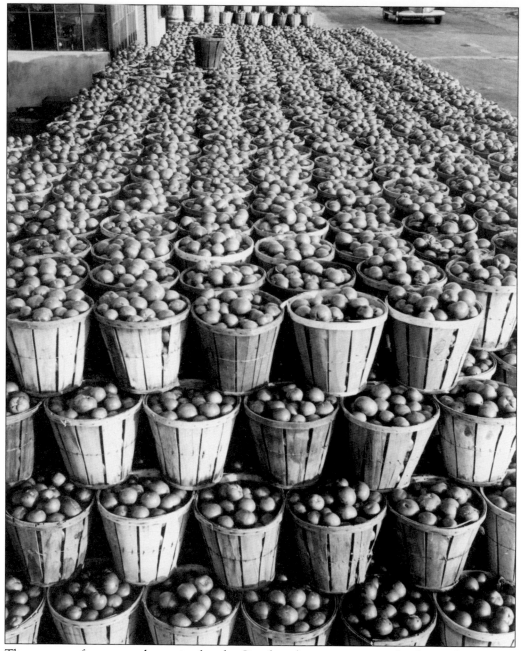

The amount of tomatoes that arrived at the Camden plant on any given day during the growing season is illustrated by the rows of bushel baskets lined up in the street outside the facility.

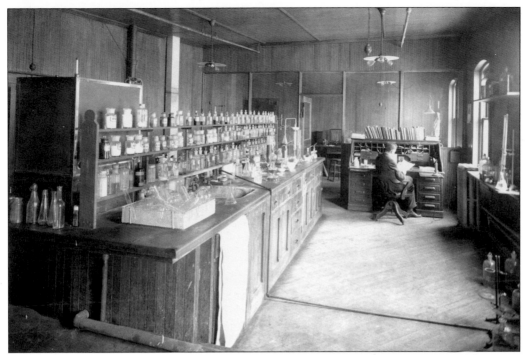

All meat and other ingredients used in Campbell soups had to be approved in this laboratory at the Camden plant, pictured in 1905. It is also where Dr. John Dorrrance conducted some of his early research work.

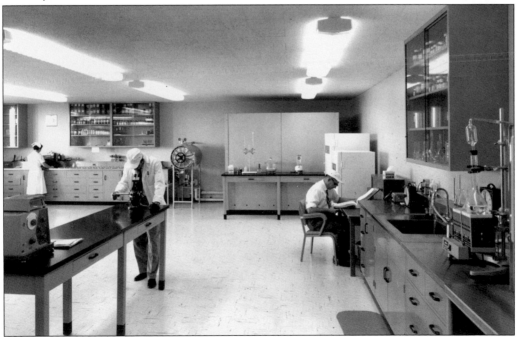

The research and development laboratory in the Listowel plant in Canada is seen in an undated photograph. Listowel was a seasonal plant operated during the tomato harvest. It is no longer in use today.

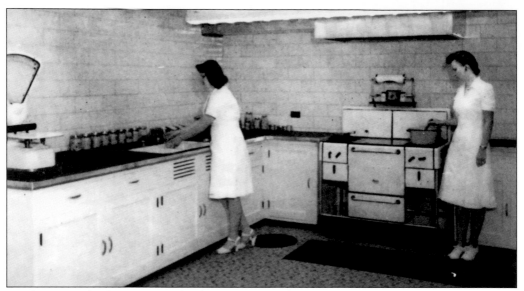

Employees in the Swanson test kitchen try out products in 1946. C.A. Swanson & Sons—an Omaha, Nebraska canning and freezing firm founded in 1899—dealt in the wholesale distribution of eggs, milk, butter, and poultry. By the time it was purchased by the Campbell Soup Company in 1955, Swanson had begun to sell complete frozen dinners in compartmentalized aluminum trays.

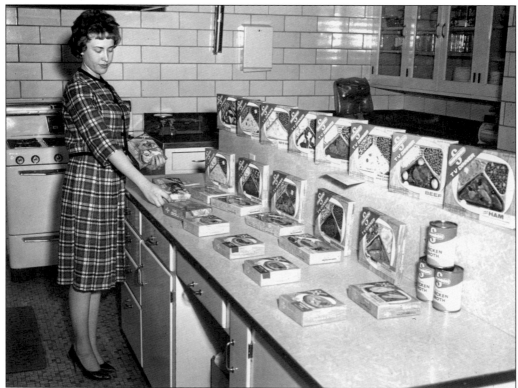

By 1962, when this photograph was taken at the Swanson test kitchen in Omaha, Nebraska, the line had expanded to include frozen pot pies and canned chicken broth.

Two

MAKING SOUP

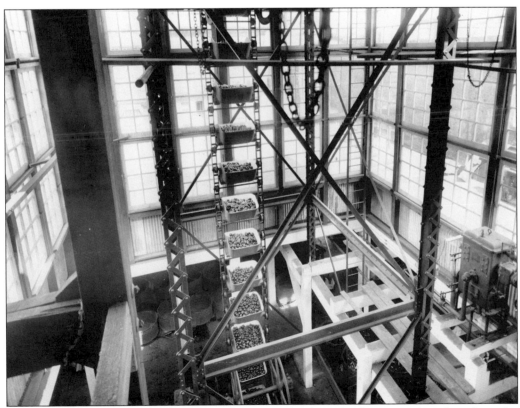

This 1905 photograph shows the tomato conveyors that brought the ripe, red produce from the receiving and grading areas of the Camden factory to processing stations.

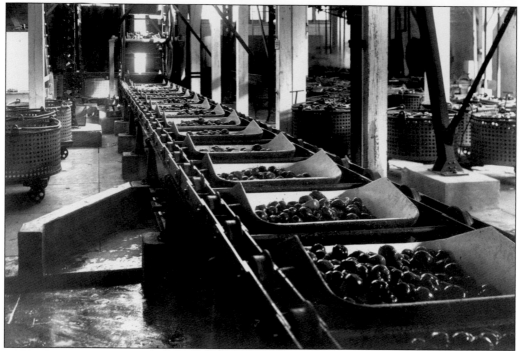

Since tomatoes have to be processed almost immediately after picking, the Campbell Soup Company had to stop production of all its other products during the harvest season to make just tomato soup. These tomatoes are seen on the conveyor line at the Camden facility in 1905.

Bushel baskets full of tomatoes were placed on a carrier from the grading platform for a short trip into the plant on their way to becoming tomato soup.

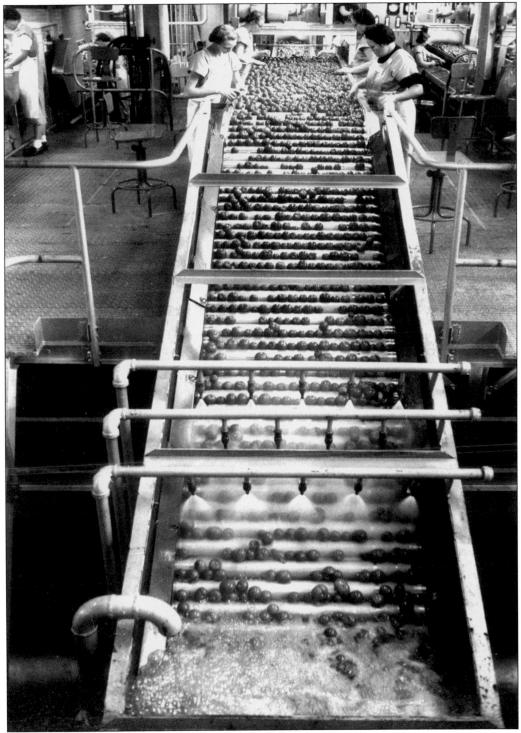

Workers look over the tomatoes as they pass through the washer. The produce was washed three times before being put on a conveyor belt that led to the inspection station.

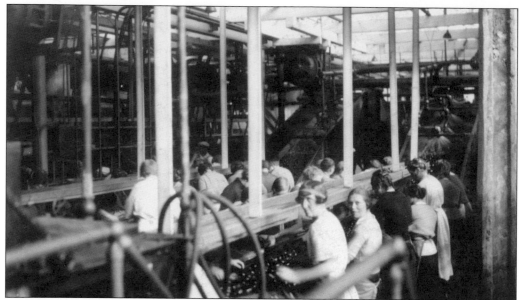

After the basket conveyor and the washer, the tomatoes went to the sorting tables, also known as inspection tables. There, workers, usually women, separated the ones that needed trimming from those that were perfect.

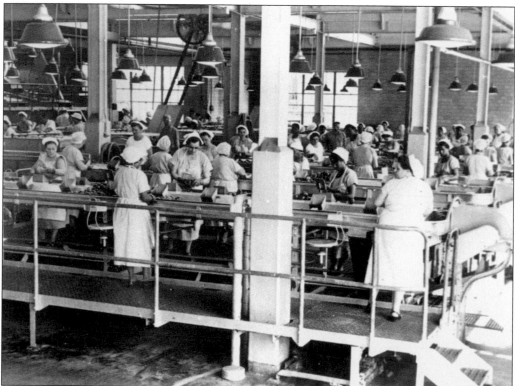

If a tomato needed trimming (as in the case of bruises or green spots), the workers would cut out the offending portion and then place the fruit back on the outside belt of the conveyor, which sent it to the processing area.

Tomato soup was the Campbell Soup Company's biggest seller. To keep the quality of the product high, the company employed many women whose sole job it was to make sure that only the best from New Jersey farms would make it through the manufacturing process.

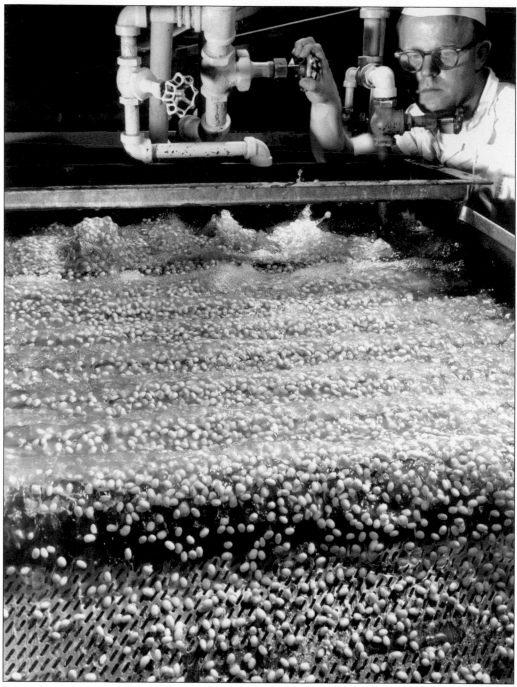

Beans for use in pork and beans are washed under the watchful eye of a Campbell Soup employee in 1940. Pork and beans is among the company's most popular products with consumers.

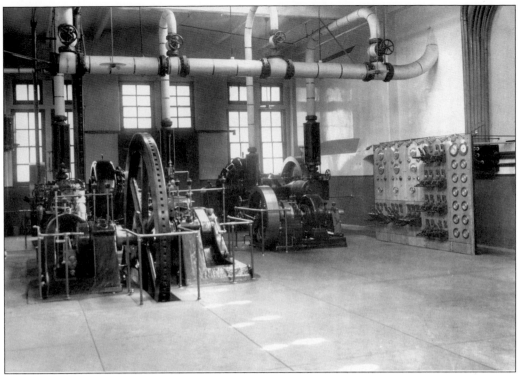

This 1905 view of the engine room at the Camden plant shows one 35-horsepower and two 150-horsepower direct-driven generators and a 110-horsepower ammonia compressor—all equipment necessary for the production of soup.

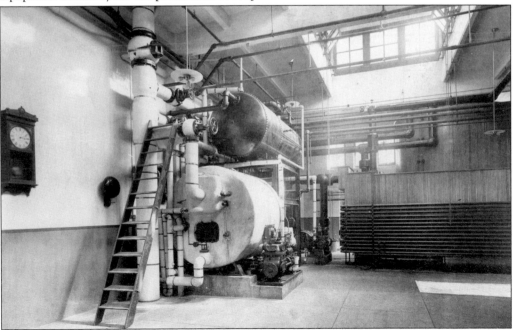

Other essential components of the manufacturing process were a refrigeration tank and heating system, shown here in 1905.

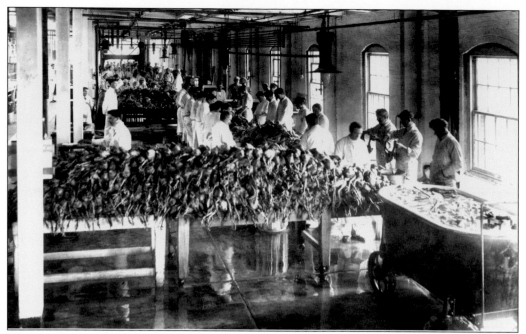

Workers prepare chicken for chicken gumbo and mulligatawny soup. Although soups featuring chicken remain popular products, Campbell discontinued the production of mulligatawny, one of its original 21 varieties, in the 1930s.

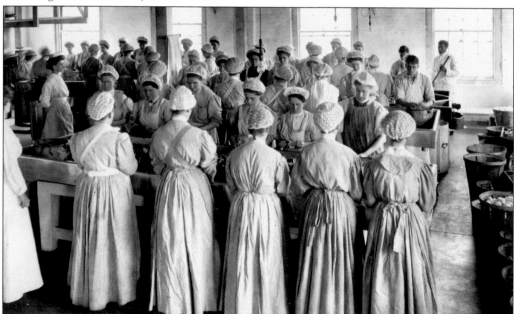

Women shred chicken for chicken soup in 1905. Although most people think of chicken noodle soup when they think of Campbell, it was not one of the company's original 21 varieties. They were asparagus, bean, beef, bouillon, celery, chicken, chicken gumbo, clam chowder, consommé, julienne, mock turtle, mulligatawny, mutton, oxtail, pea, pepper pot, printanier (beef broth with vegetables), tomato, vegetable, vegetable beef (which replaced clam bouillon in 1918), and vermicelli tomato.

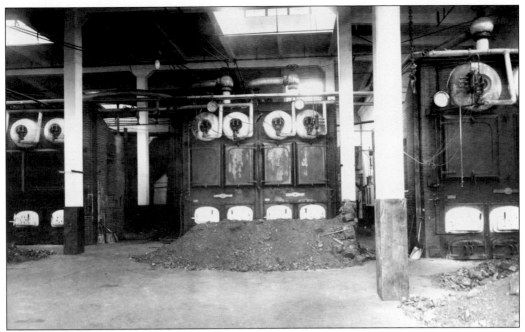

This 1905 photograph shows the boiler room at the plant. Each of the boilers had a capacity of 1,100 horsepower and consumed 20 tons of a coal a day.

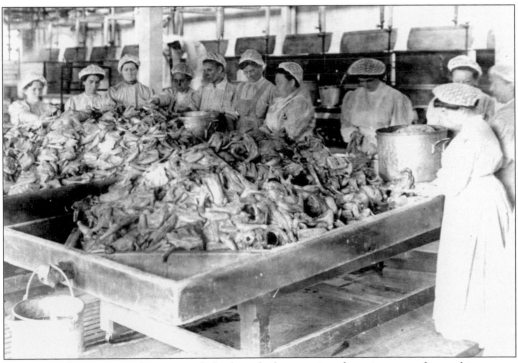

Factory workers inspect the prepared chickens before putting them into pots for cooking.

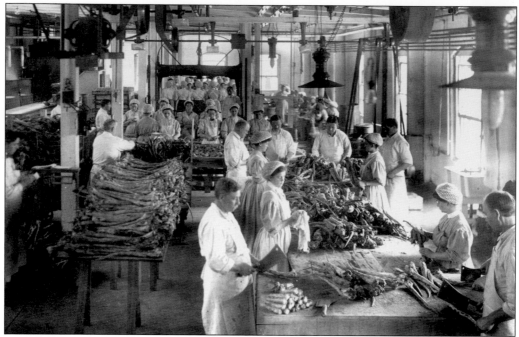

In a scene from 1905, butchers prepare to chop oxtails for use in oxtail soup, one of the original 21 varieties of condensed soup.

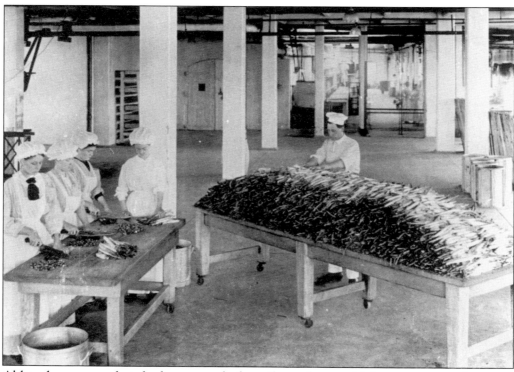

Although many people today have never had oxtail soup (nor would they want to try it), it was a popular choice with soup buyers in 1905, when this photograph was taken at the Camden plant.

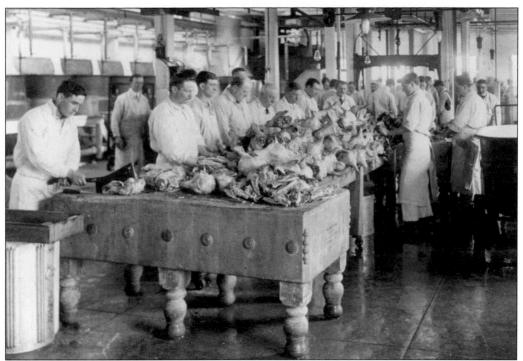

Butchers prepare calves heads for use in mock turtle soup, another of the original 21 varieties that eventually fell out of favor with shoppers.

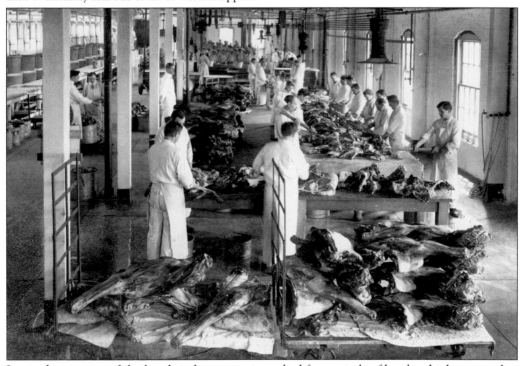

In another section of the butcher shop, meat is readied for use in beef broth, which was used as the base for many of the company's soups.

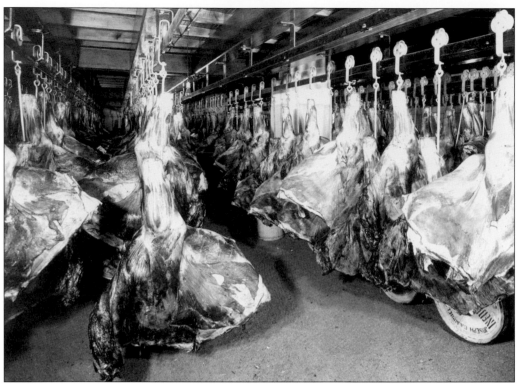

This 1905 view shows a corner of the cold-storage plant at the Camden facility. The room had a capacity of 30 train boxcars full of beef.

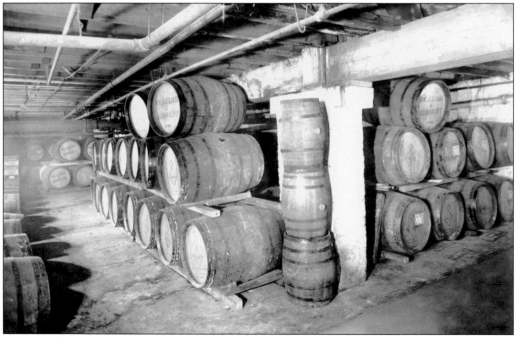

Casks of sherry imported from Spain, for use in soups such as mock turtle, rest in a portion of the company's wine cellar.

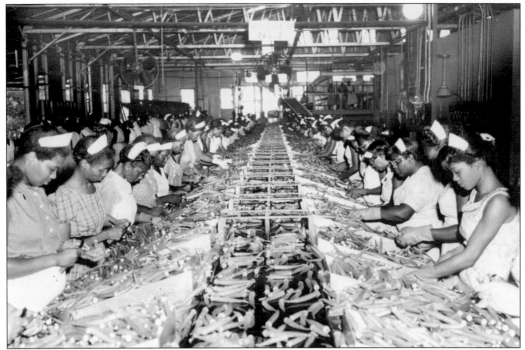

In this 1940 view, workers at the Camden plant ready carrots for use in vegetable soup. Note that some employees wore gloves while working, but others did not.

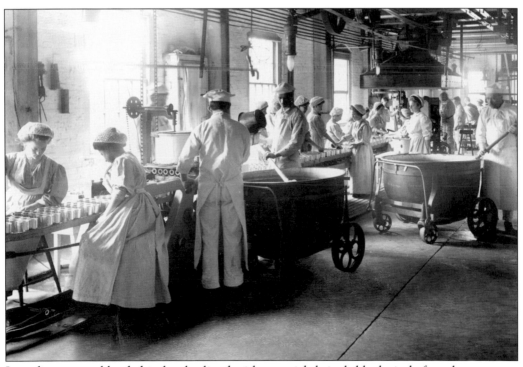

Ingredients were blended in kettles lined with one-eighth-inch block tin before the soup was filled in the cans. The capacity of each kettle was 110 gallons.

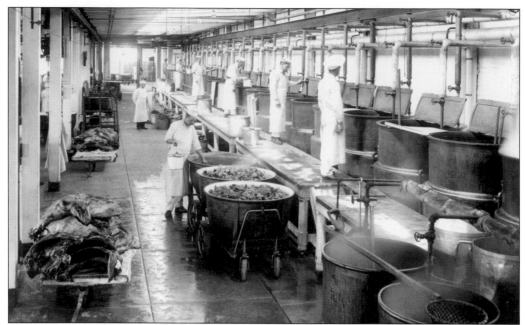

Soup was cooked in the battery of 28 cauldrons, each with a capacity of 220 gallons.

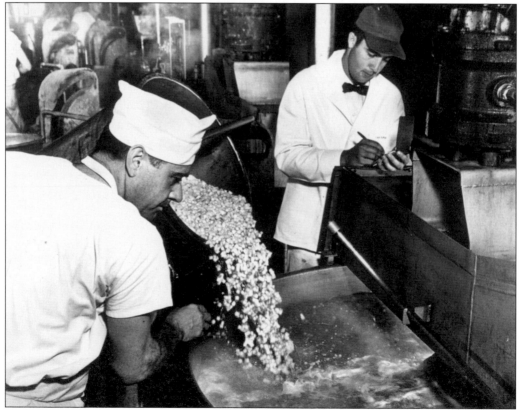

In this 1940 photograph, a cook adds corn to a blending kettle as another employee makes a note of the addition.

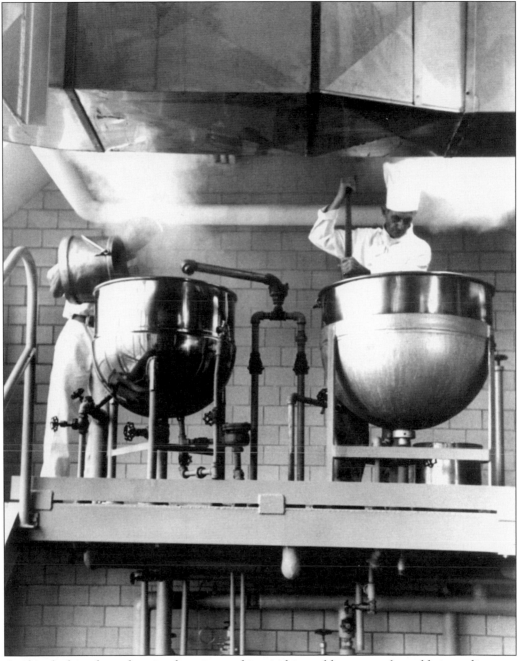

As the chef on the right stirs the soup cooking in his cauldron, a worker adds ingredients to another kettle. This photograph was taken at the Camden plant in 1940.

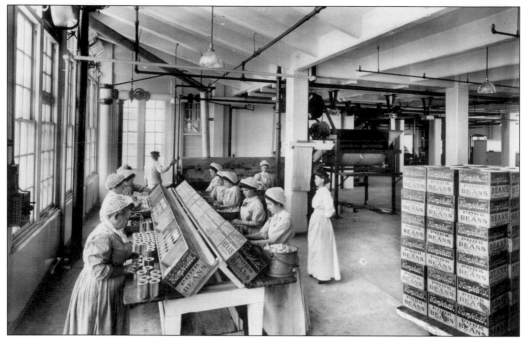

Women place pieces of pork in cans of pork and beans. The product was added to the Campbell line after Dr. John Dorrance realized that workers were left with nothing to do while soup stock simmered. He therefore introduced pork and beans, which could be made while the soup cooked. It became a popular addition to the company's line, totaling more than $2.2 million in sales in 1914. That year, the total sales for Campbell reached $5.7 million.

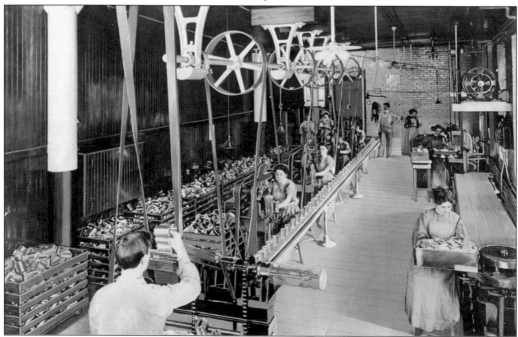

Workers scale, or measure out, ingredients before placing them in cans. This action took place next to the filling machine, where soup was added to the cans.

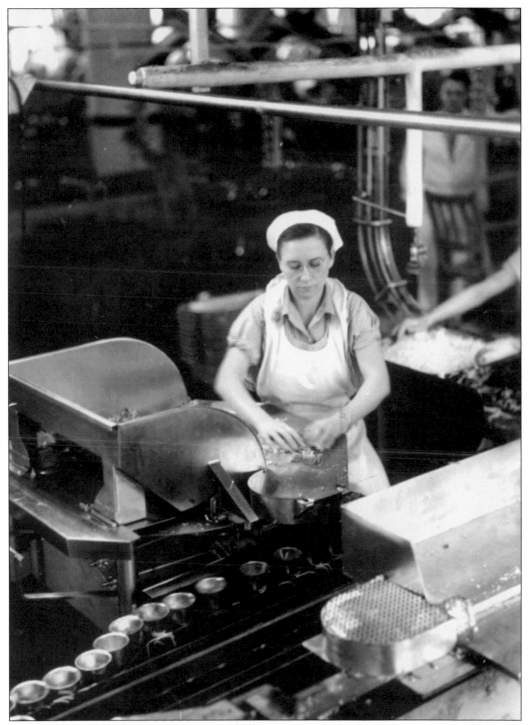

Before automation came to the process of filling cans in the early 1940s, workers had to scale ingredients, such as the noodles for chicken noodle soup, before putting them by hand into cans that then went on to be filled with soup.

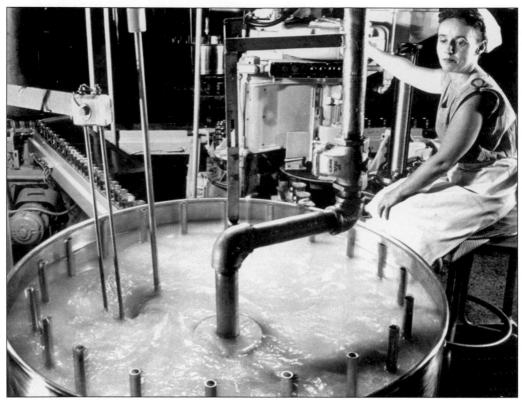

Automation made it easy for cans to be filled. A can is positioned under every tube in the soup "bowl." The tubes allow air to escape from the cans before they are sealed.

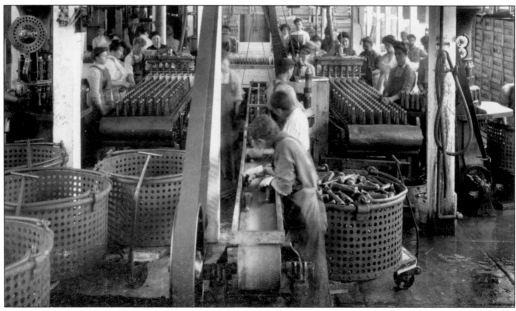

Among the early products produced by the company was tomato ketchup. Here, bottles are filled and capped.

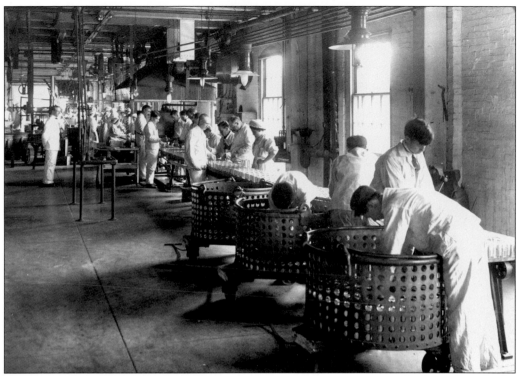

This 1905 photograph shows the filling and capping machines in action. Each machine had a capacity of 500 cans a minute.

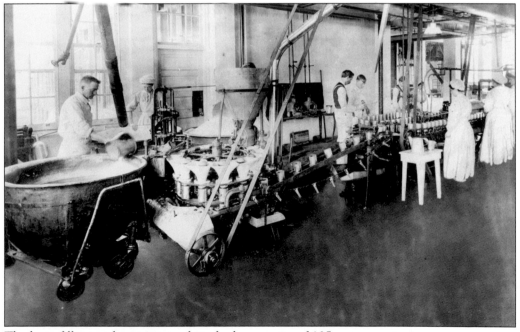

The bean filling and capping machine had a capacity of 105 cans per minute.

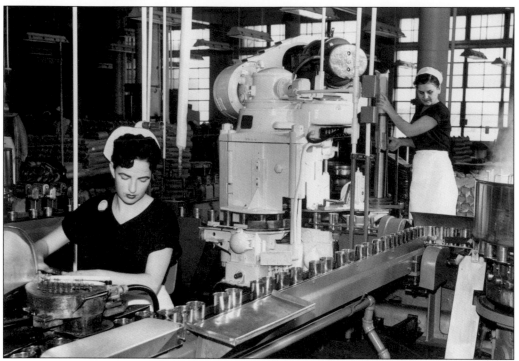

Sacramento, California plant workers Lettie Coffey (left), who was hired in 1955, and Verna Ollar, who joined the company in 1951, operate a filling machine in 1958.

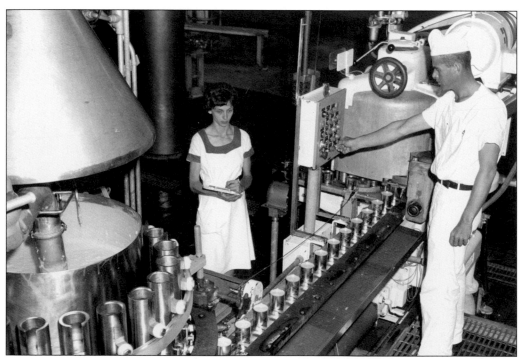

At the Paris, Texas facility in 1965, a quality-control worker (left) oversees the placing of blended soup into cans at the filling machine.

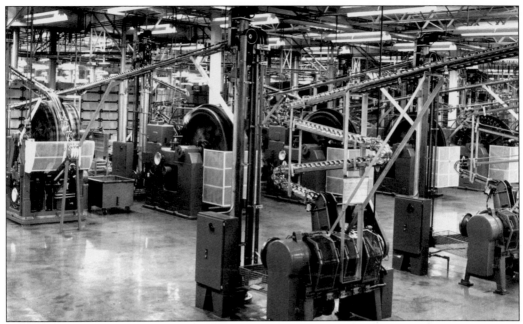

The can-manufacturing portion of the Paris, Texas plant is seen in 1965. The Campbell Soup Company began making the cans for its products in 1936.

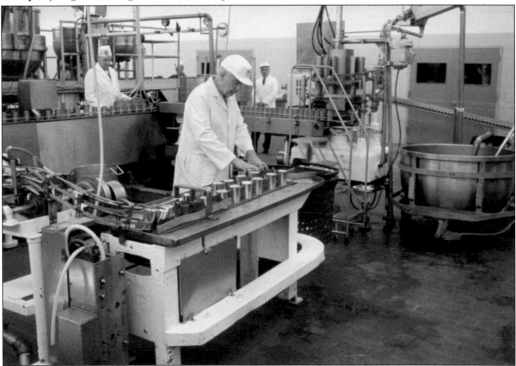

This is the filling and canning line at the pilot plant, opened in Camden in 1971 as part of the company's new research facility. The plant is where new products are created and produced before they are manufactured at other Campbell facilities. Soup went from the blending platform to a soup car (right) and then to the filling machine, where it was placed in cans and sealed.

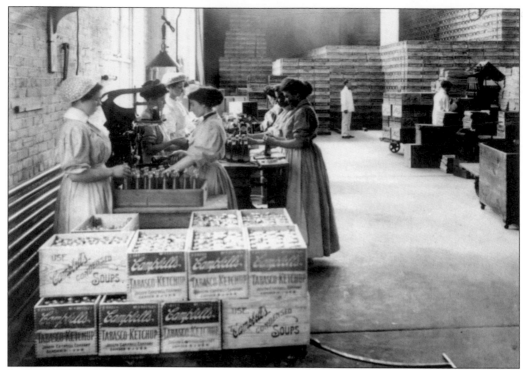

In this 1905 view, ketchup is being labeled and packaged by hand prior to distribution.

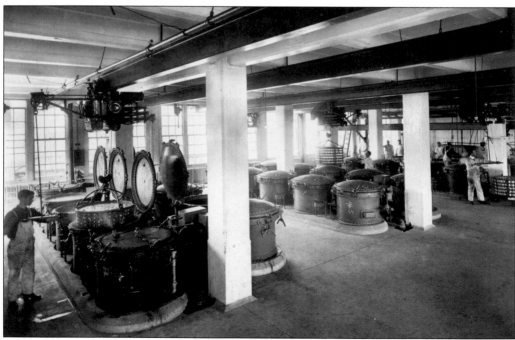

Sterilizing retorts, or commercial pressure cookers, were handled by electric cranes and could sterilize 2,238 cans at a time. Since the pressure outside the can could be matched in the retort by the pressure outside of the can, explosions of boiling cans became less likely.

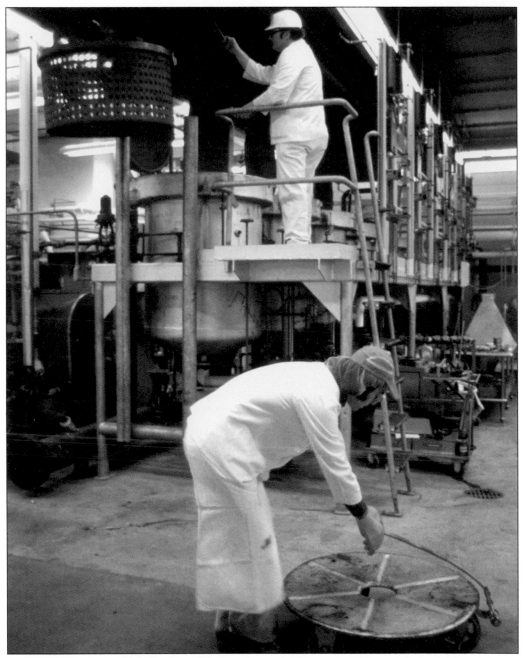

In this 1980s photograph, baskets filled with cans go from the filling and closing machine to the retort. The company began manufacturing its own cans in 1936, and they could effectively go from production to filling in just minutes.

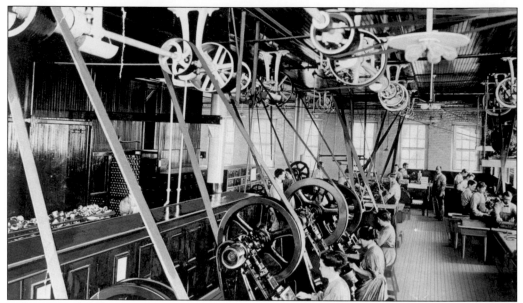

Before 1900, labeling was handled by workers using machines that operated off a pulley system.

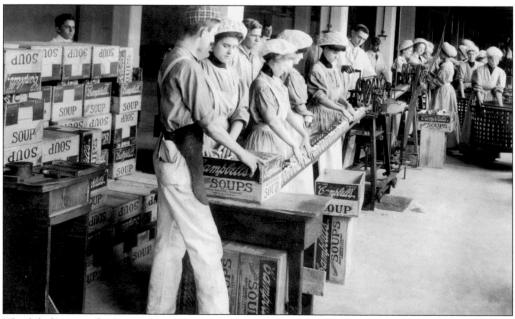

The labeling machines, seen in 1905, had a capacity of 350,000 cans per day.

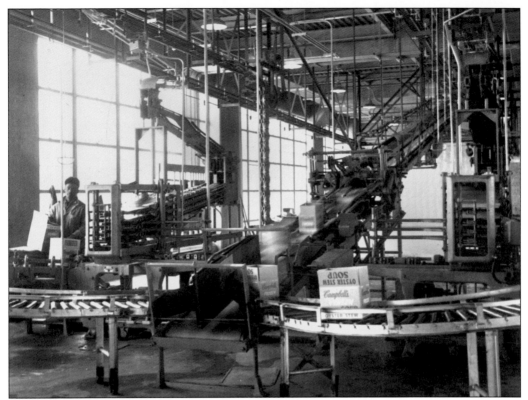

Cartons of oyster stew enter the final phase of production as they are readied for shipping to grocers in 1940. Although oyster stew is not widely available in stores today, it remains in production.

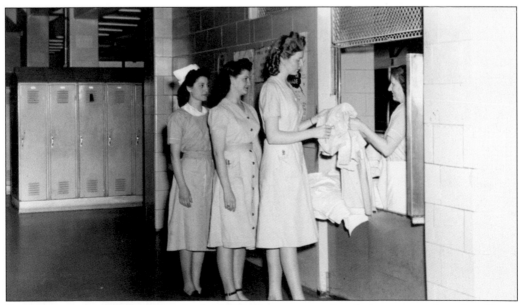

Employees at the Camden plant in the 1950s line up to receive their company-issued uniforms in the women's locker room.

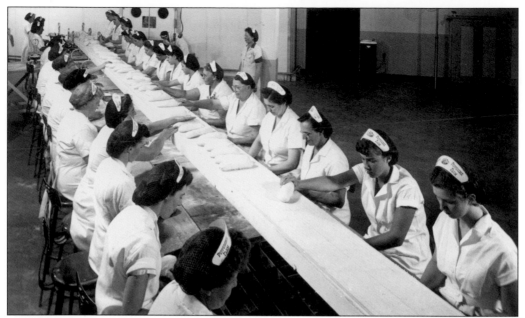

Pepperidge Farm employees hand-knead bread dough in this 1950s photograph.

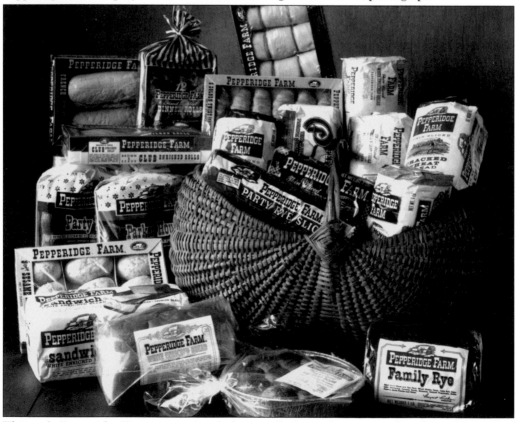

This early Pepperidge Farm promotional photograph shows the variety of products that carried the name, from party rye and dinner rolls to sandwich bread.

Three

REGIONAL FACILITIES

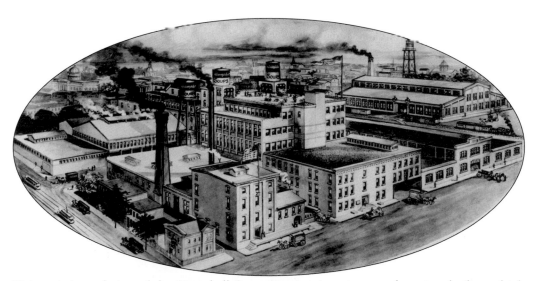

This artist's rendering of the Campbell Soup Company's main manufacturing facility, which was located along the Delaware River in Camden, New Jersey, was drawn in the late 19th century. On the roof of the factory are three water towers that resemble soup cans, and horse-drawn wagons are delivering produce grown on southern New Jersey farms. Today, housing developments, shopping centers, and office complexes occupy the once fertile farmland that yielded vegetables for a variety of Campbell soups.

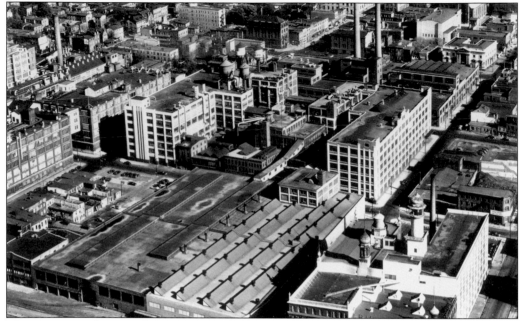

This is an aerial view of the Campbell Soup Company's Camden, New Jersey facility. The company located on the river prior to 1900, when it was still known as the Joseph Campbell Preserve Company. At the time of its construction, the Campbell plant was an integral component of a thriving industrial base on the Camden waterfront, which also included a furniture factory, a shipbuilding yard, and the Victor Talking Machine Company.

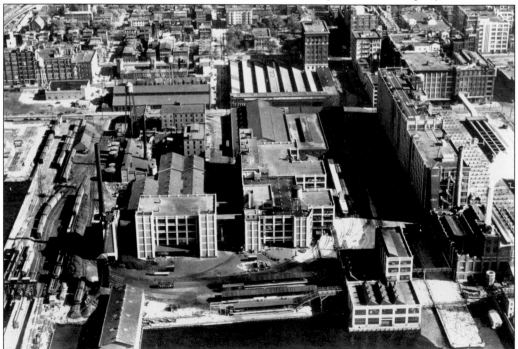

Pictured is another portion of Campbell's massive waterfront production facility in Camden, New Jersey.

50

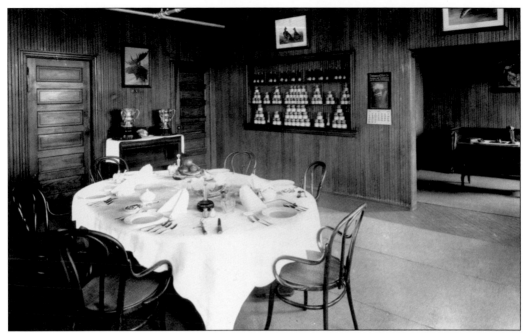

This dining room, shown in 1905, was where Campbell Soup Company executives ate their meals in the early 20th century. Notice the cans of soup stacked in small pyramids on the wall and the soup tureens resting on the table in the back.

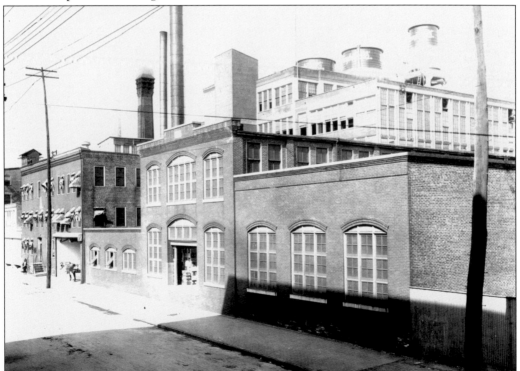

This ground-level photograph of the Camden facility was taken in 1916. Visible are boxes of prepared items at the loading dock and a horse farther down the block.

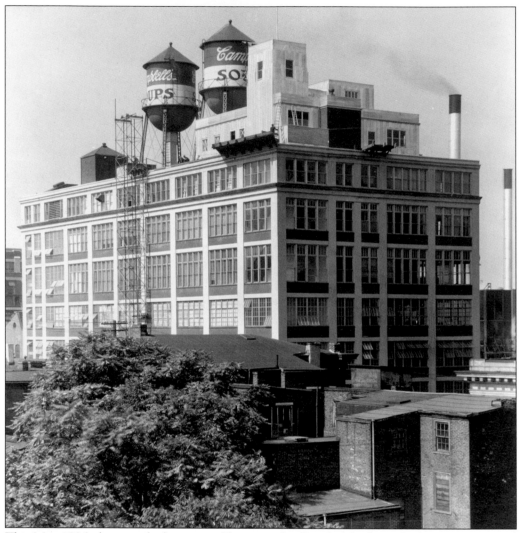

This May 1936 photograph shows an addition to the Camden facility, which was constructed to accommodate the continued growth of the company and its product line. Two years earlier, Campbell introduced chicken noodle and cream of mushroom soups, which remain two of its most popular varieties.

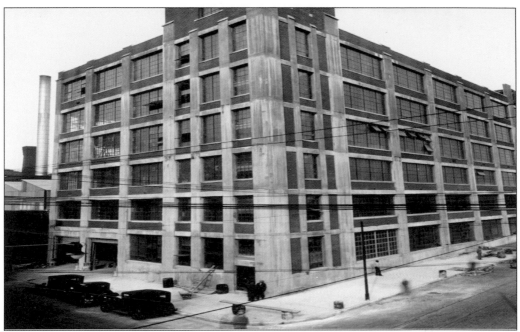

This photograph shows the six-story canning plant in Camden, New Jersey, in June 1931. In its early days, Campbell purchased its cans from the Continental Can Company, which built facilities next to Campbell plants in Camden and Chicago in the late 1920s. The company bought the two can-producing factories in 1936. By the late 1940s, Campbell Soup was the third largest producer of cans in the world.

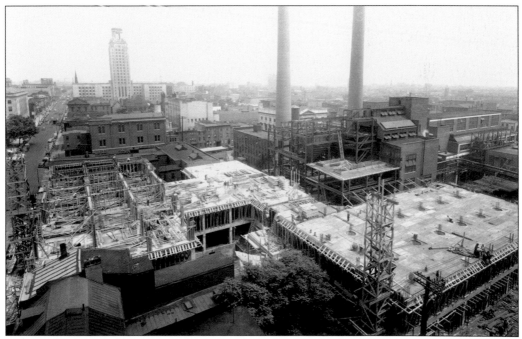

To accommodate the company's increasing production, Campbell Soup constructed this addition to its boiler plant in Camden, New Jersey, in June 1941.

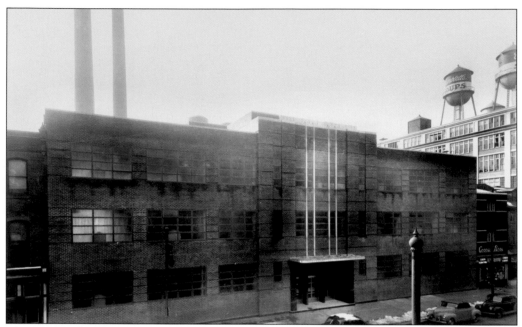

The service building adjoining the Camden, New Jersey factory contained the company's personnel offices, a cafeteria, and locker rooms when this photograph was taken in January 1942. The company relocated its corporate headquarters from its massive waterfront facility to another location in Camden in 1957, the same year it established its international division.

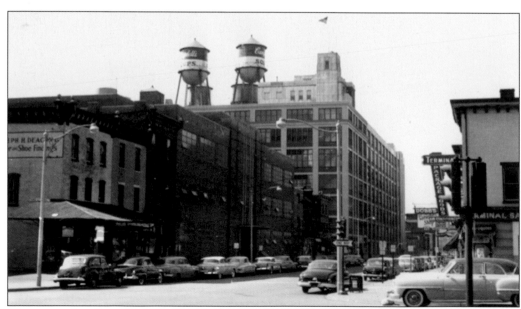

This street-level view shows Campbell Soup Company plant No.1 in Camden in 1955. (Courtesy of Harry Nelson.)

Campbell Soup Company plant No. 2, located along the Delaware River in Camden, New Jersey, produced a variety of products, including V8 vegetable drink, ketchup, pork and beans, mushroom soup, and Franco-American spaghetti. The facility was built in the 1920s for the processing of tomato pulp. (Courtesy of Harry Nelson.)

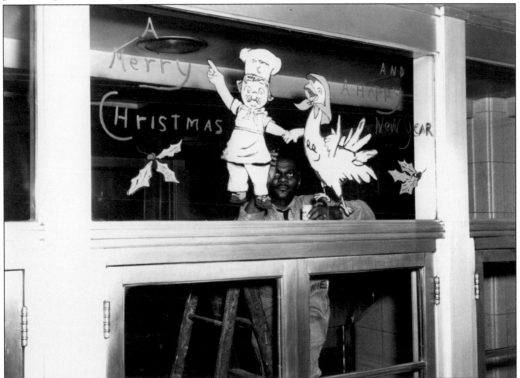

Campbell employee Ernie Fair paints an image of one of the Campbell Kids as part of a holiday display at the Camden, New Jersey headquarters. The Campbell Kids have been one of the most enduring advertising vehicles in American history.

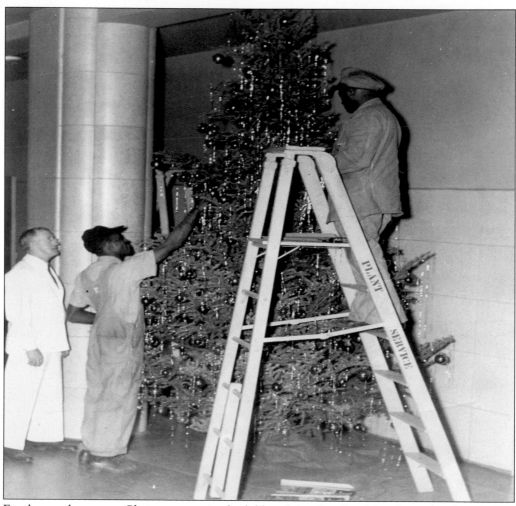

Employees decorate a Christmas tree in the lobby of the Camden, New Jersey headquarters in the 1950s.

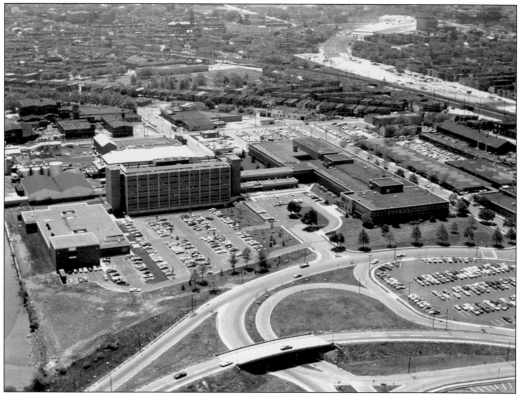

This aerial view of the Campbell Soup Company general offices was taken in 1971. The company relocated its corporate headquarters from the Delaware River manufacturing facility in 1957 to a location about a mile away within the Camden city limits.

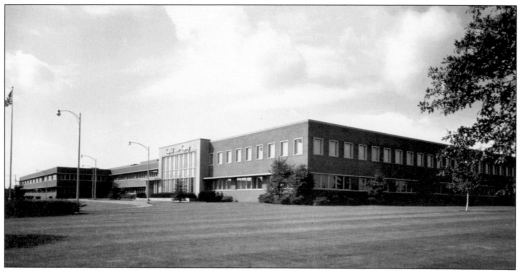

This is a ground-level photograph of the main entrance of the general offices.

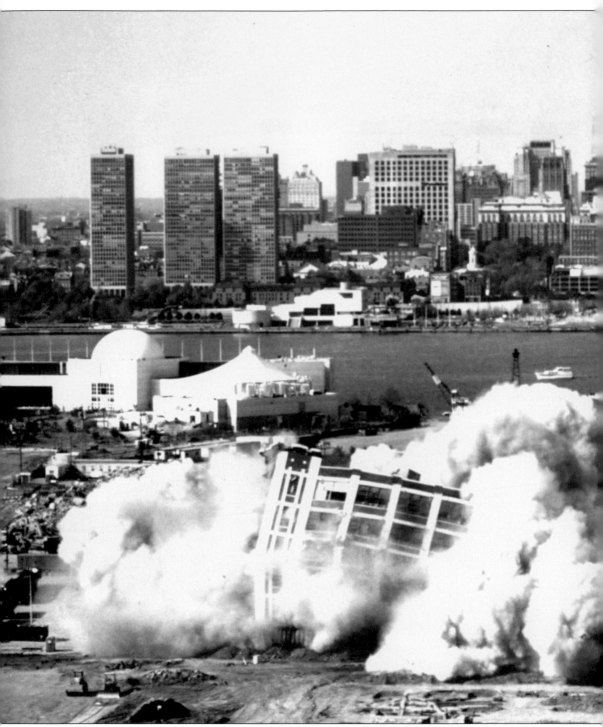

The remainder of the Campbell Soup Company's Camden, New Jersey manufacturing plant was imploded in November 1991. The Philadelphia skyline can be seen in the background as the eight-story building is reduced to rubble by a series of dynamite charges. The facility had been shuttered in 1990 after soup-making operations shifted from Camden to other Campbell

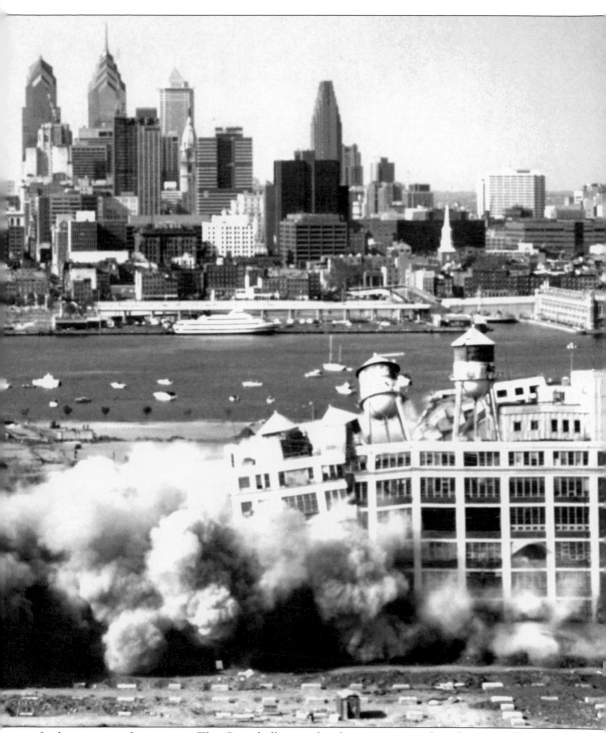

facilities across the country. The Campbell name has been perpetuated at the site, which is now the location of Campbell's Field, home of the Minor League baseball team the Camden Riversharks. (Courtesy of Dennis McDonald.)

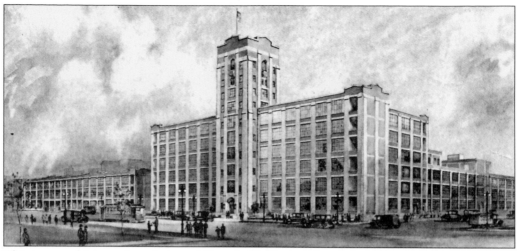

This is an architectural rendering of Campbell's Chicago factory, which was built in 1929. The facility was constructed to help the company better meet the increasing demand for its products to a growing national consumer base. (Courtesy of Harry Nelson.)

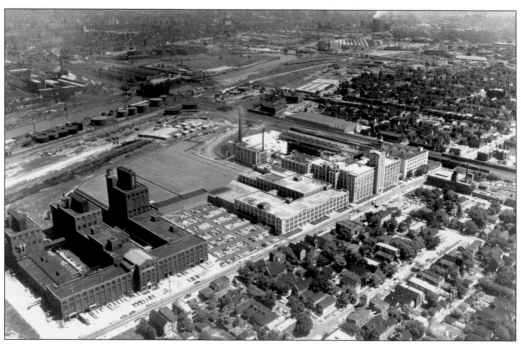

This is an aerial view of the Campbell Soup Company's Chicago manufacturing facility.

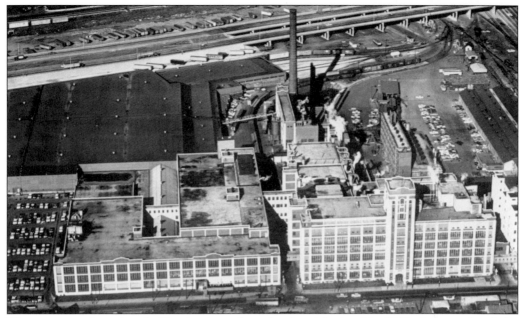

The can-manufacturing facility is pictured at the far right in this 1969 photograph of the Chicago facility. Cans traveled through a conveyor into the plant, where they were filled with soup that had been made just minutes earlier.

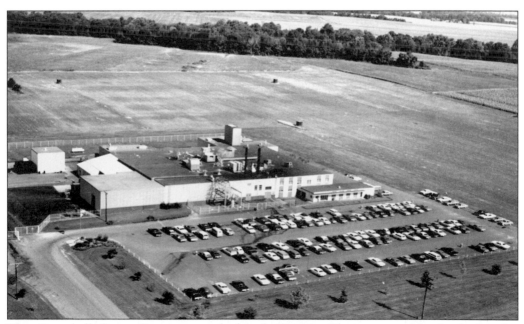

The Campbell Soup Company used this facility in Chestertown, Maryland, for the production of poultry. The poultry was selected, cooked, diced, and then shipped to Campbell soup-production facilities for further processing. Broth canning was also done here. The facility, pictured in 1970, has since been sold.

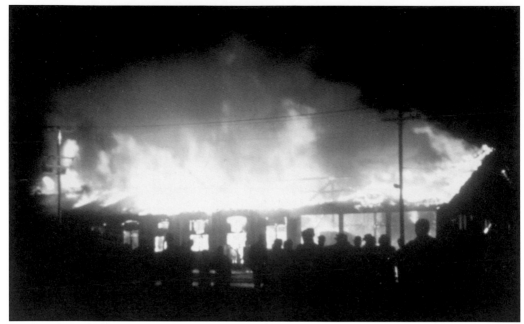

Fire destroyed the company's Terre Haute, Indiana plant on November 11, 1953. The facility was the home plant for V8, which was purchased by Campbell from Standard Brands. Pork and beans were manufactured at the facility during the winter. (Courtesy of Harry Nelson.)

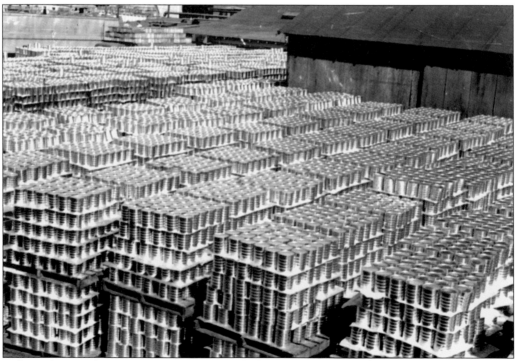

Pallets of canned tomato pulp sit in the yard of the Terre Haute plant after the fire in 1953, a banner year for tomatoes. (Courtesy of Harry Nelson.)

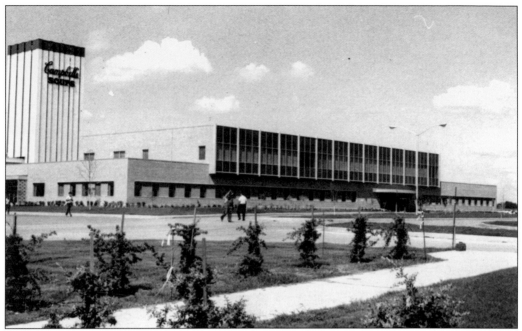

The Paris, Texas plant produces a full line of products for the Campbell Soup Company and is a major facility for the production of Prego tomato sauce. The Prego line was introduced in 1981 as a vehicle for the company to enter the jarred spaghetti sauce market. The recipe for the sauces was based on a family favorite of one of Campbell's chefs. (Courtesy of Harry Nelson.)

The company operated this okra plant in Cairo, Georgia, in the 1920s. Okra, an American vegetable normally associated with Louisiana cuisine, was used in the production of tomato okra and chicken gumbo soups.

The Swanson plant in Omaha, Nebraska, produced chicken pot pies, broth, and canned chicken. Campbell acquired C.A. Swanson & Sons in 1955, six months after Campbell Soup became a public corporation. Swanson was founded in 1899 by a Swedish immigrant who built the company into what is perhaps best known for its TV and Hungry Man dinners. In 1998, Campbell announced a spin-off of Vlasic Foods International, a $1.4 billion company that included Vlasic, Swanson, and Swift-Armour brands. (Courtesy of Harry Nelson.)

Swanson's plant No. 2 in Omaha was used for the production of TV dinners, one of the company's best-known and profitable products. (Courtesy of Harry Nelson.)

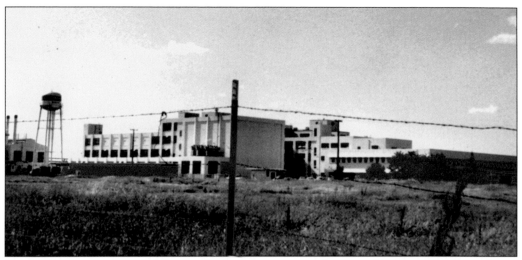

Campbell's Sacramento, California plant produces a complete soup line and tomato products, such as paste and pulp, which are shipped to other plants across the nation for use in manufacturing. The plant was opened in 1947. (Courtesy of Harry Nelson.)

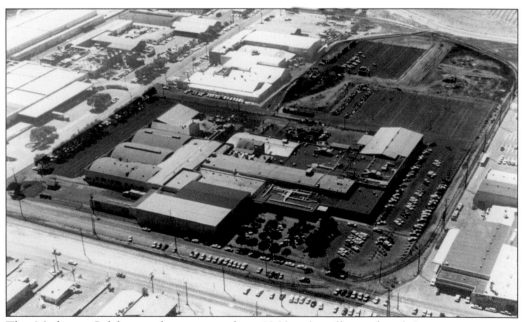

The Modesto, California plant, pictured in 1966, originally produced Swanson products, primarily turkey TV dinners.

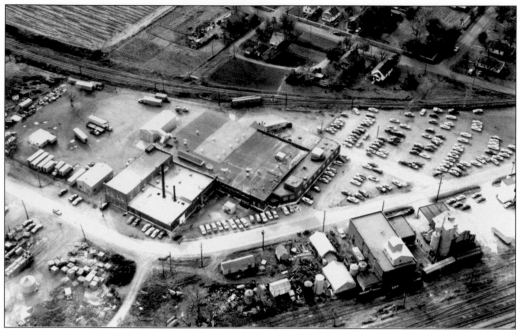

This processing plant in Fremont, Nebraska, prepared poultry for use at Campbell Soup's Midwest facilities.

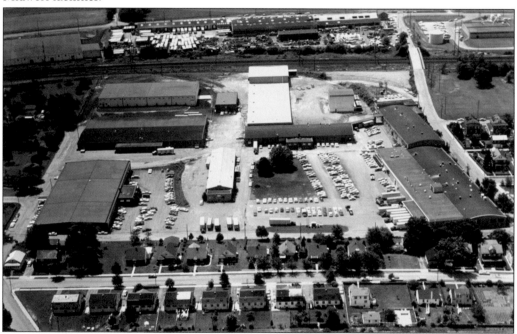

This factory in Downingtown, Pennsylvania, was the main facility for the production of Pepperidge Farm bakery products. Pepperidge Farm was founded by Margaret Rudkin, who started the company in the kitchen of her Connecticut home in 1937 after she was unable to find a wholesome loaf of commercial bread on the market. The company was named for the pepperidge trees that grew in the yard of her home. The Campbell Soup Company purchased Pepperidge Farm in 1961.

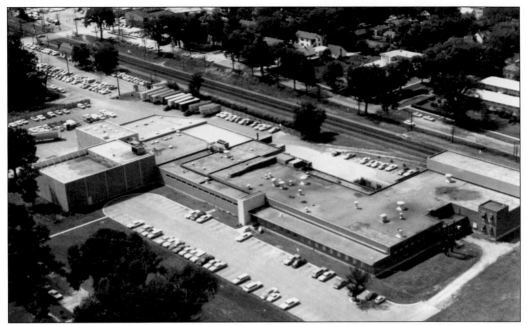

Pepperidge Farm's Downers Grove, Illinois production facility was built to serve Midwest customers hungry for the company's breads, cookies, rolls, and frozen pastries.

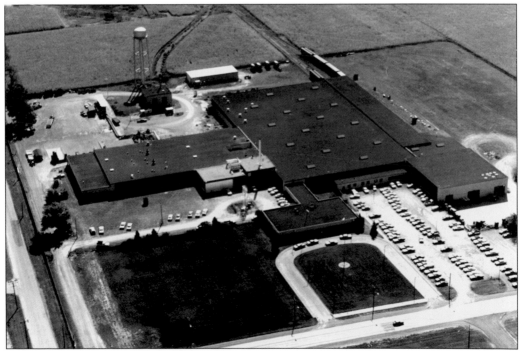

This facility in Chatham, Ontario, was acquired when the Campbell Soup Company purchased V8 vegetable juice in 1948. V8 juice and tomato soup are manufactured at the Canadian facility.

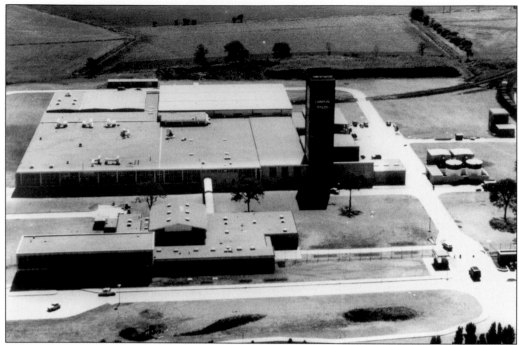

Opened in 1959, the King's Lynn plant in Norfolk, England, is used to produce soup products. Condensed canned soup had become popular in European homes by the 1930s.

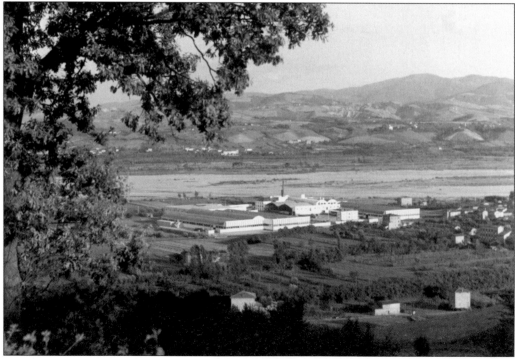

Another facility Campbell Soup constructed in Europe was this plant in Felegara, Italy. The plant, which was built in 1965, was used for tomato processing. Some of the tomatoes were shipped from here to the United States for further processing.

Four

CAMPBELL PEOPLE

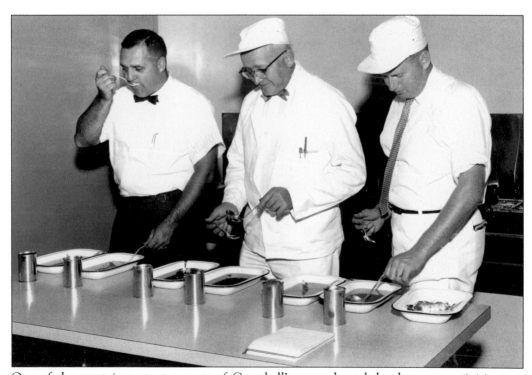

One of the most important aspects of Campbell's research and development activities was tasting varieties of new soups. Here, three tasters sample varieties of soup in the company's Listowel, Canada test kitchens sometime in the 1950s.

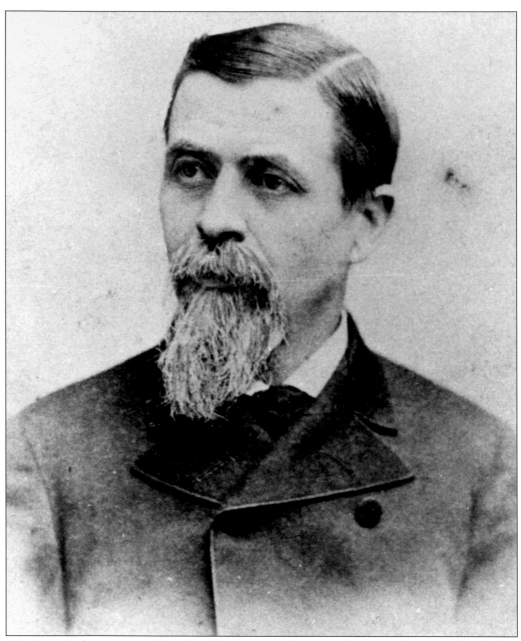

Abraham Anderson was a Camden, New Jersey icebox manufacturer who teamed with fruit merchant Joseph Campbell in 1869 to form Anderson & Campbell, a company that canned tomatoes, jellies, condiments, and mincemeat. The company was awarded a medal for quality at the Centennial Exposition in Philadelphia in 1876–1877. A disagreement between the partners over expansion of the firm led to Campbell's buyout of Anderson in 1876. Born in 1834, Anderson had been trained as a tinsmith and spent several years fabricating and installing roofs before beginning to manufacture refrigerators in 1860. Two years later, he opened a canning plant. Anderson formed another partnership and packed fruits, vegetables, preserves, and jellies. A successor company, the Anderson Preserve Company, remained in business until 1904.

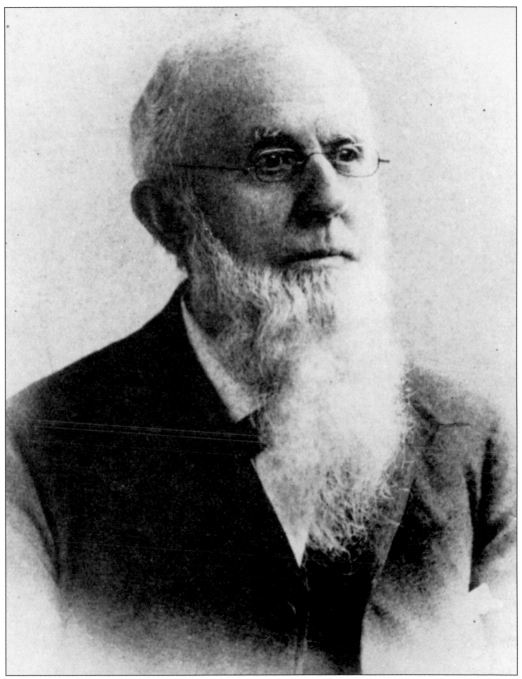

Joseph Campbell was a Camden, New Jersey fruit merchant who partnered with icebox manufacturer Abraham Anderson in 1869 to form Anderson & Campbell. Reared in Cumberland County, New Jersey, Campbell moved to Philadelphia as a young adult to become a traveling purchasing agent for a produce wholesaler. When Anderson left the partnership in 1876, Campbell acquired the company's buildings, equipment, and recipes. In 1891, the company name was changed to the Joseph Campbell Preserve Company. Campbell retired from the company in 1894 and died in 1900.

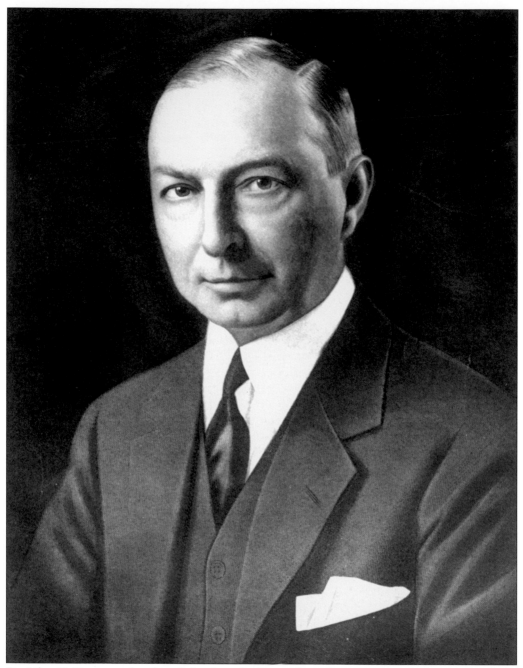

Dr. John T. Dorrance developed the formula for condensed soup, a process that removed the water from soup before it was canned and allowed the cans to be smaller and the product less expensive. Dorrance was 24 years old when he was hired by his uncle Arthur Dorrance to work for the Joseph Campbell Preserve Company as an industrial chemist at a wage of $7.50 per week. His invention and advertising acumen would catapult the company into one of the world's best-known corporate institutions. Dorrance assumed the presidency of the company in 1914. During his presidency, the company adopted *soup* as its middle name, becoming the Campbell Soup Company. Dorrance died in 1930.

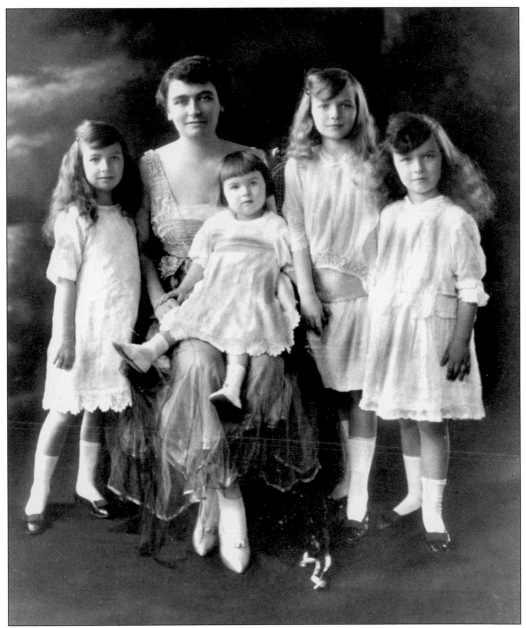

Shown in 1916 are the wife and four daughters of Dr. John T. Dorrance. John Dorrance married Baltimore socialite Ethel Malinckrodt in 1906. The couple first lived in an apartment in Camden, New Jersey, before moving to a 176-acre farm in Cinnaminson, New Jersey, where Dorrance planted and tended tomatoes, searching for the perfect strain for tomato soup. The family grew to include a son, and Dorrance eventually moved his family to Radnor, Pennsylvania, on Philadelphia's Main Line.

Dynasty of Soup

GEORGE MORRIS DORRANCE

JOHN THOMPSON DORRANCE JR.

ARTHUR C. DORRANCE

FIVE years after his death, the Dorrance family still revolves about Dr. John T. Dorrance, as always it did in his lifetime. The center picture right is of his only son, currently sixteen, and a student at St. George's in Newport. Below him is pictured his mother, and flanking him on either side his two uncles. These three are the only individual trustees and executors of his father's $120,000,000 estate. In 1944, when he is twenty-five, he will join them to make a fourth. (Corporate trustee is the Camden Safe Deposit & Trust Co.)

At the bottom of the page are Dr. Dorrance's daughters. Daughter Elinor, the eldest, married Nathaniel Peter Hill, grandson of Colorado's onetime Senator Nathaniel P. Hill. Daughter Ethel is Mrs. Tristram C. Colket, whose husband is with the Philadelphia brokerage firm of Montgomery, Scott & Co. Daughter Charlotte is Mrs. William Coxe Wright, whose husband won the national court-tennis singles championship in 1931, and (with Jay Gould) the doubles championship also. Daughter Peggy, who was christened Margaret, is currently twenty and unmarried, is fond of horses and of riding fast in automobiles.

Neither uncle is directly a beneficiary of Dr. Dorrance's will, but Dr. Dorrance's wife

MRS. JOHN THOMPSON DORRANCE

and children were generously provided for, according to the details given on page 136. Yet no one on this page will ever inherit the Campbell Soup Co. which Dr. Dorrance built to greatness. His will expresses the hope that his son will be given opportunity to learn the soup business, and will demonstrate a capacity to take an important part in its management. But ownership of the Campbell Soup Co. resides in the estate. The will provides that no one who is a beneficiary shall have any power to interfere with or control the declaration of Campbell dividends. And the trusteeship to which Dr. Dorrance's whole estate was left is never to be dissolved until the youngest child of each of his children shall have reached the age of twenty-one.

Should the trustees ever find it necessary to sell the Campbell Soup Co., they must be guided so far as possible by Dr. Dorrance's will, which lays upon them the moral injunction to sell it in one block, or at least to retain a minimum of 52 per cent of it. And thus it is that no Dorrance can ever again personally own Campbell Soup as Dr. Dorrance owned it—which was lock, stock, and barrel, with no penny of indebtedness to anyone, and 99.9991 per cent of all its voting stock in his personal possession.

Photographs by R. H. Hoffmann

DAUGHTER ELINOR
(Mrs. Nathaniel P. Hill)

DAUGHTER ETHEL
(Mrs. Tristram C. Colket)

DAUGHTER CHARLOTTE
(Mrs. William Coxe Wright)

DAUGHTER PEGGY
(Twenty and Unmarried)

"Dynasty of Soup"—describing Dr. John T. Dorrance's family, financial holdings, and accomplishments—appeared in a publication in 1935. At the time, the Dorrance estate was worth $120 million. Pictured here are Dorrance's son John T. Dorrance Jr., his mother, and four sisters. Also shown are two uncles, George Morris Dorrance and Arthur C. Dorrance. Arthur Dorrance succeeded Dr. John T. Dorrance as Campbell president when John Dorrance died in 1930.

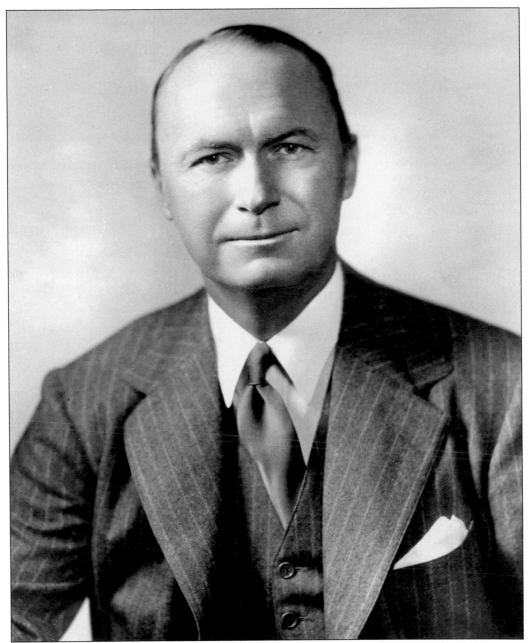

Arthur C. Dorrance succeeded his older brother Dr. John T. Dorrance as president of the Campbell Soup Company in 1930. Arthur Dorrance joined the company in 1920 and served as a vice president before assuming the presidency. His tenure was marked by the Great Depression and competition in the condensed soup market for the first time. Arthur Dorrance died in 1946 and was succeeded as president by James McGowan Jr.

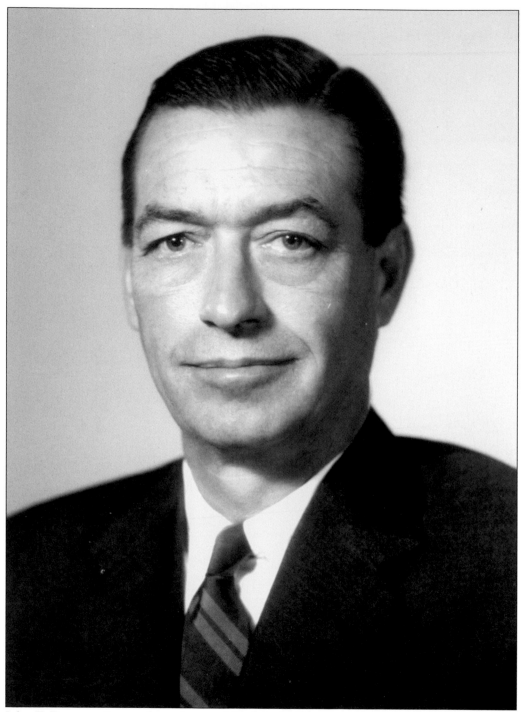

John T. Dorrance Jr. was the only son of Dr. John T. Dorrance. He served as chairman of the board of the Campbell Soup Company from 1962 until his retirement in 1984. Dorrance and William B. Murphy developed the idea for the Campbell Museum, an impressive collection of pottery, porcelain, and soup tureens from around the world. The museum opened in 1970. John T. Dorrance Jr. died in 1989.

An heir to the Strawbridge and Clothier retailing fortune, George Strawbridge married John T. Dorrance's daughter Margaret Dorrance and fathered two children with her—George Dorrance Jr., born in 1937, and Diana Dorrance, born in 1939. For many years, Strawbridge himself took a role in the day-to-day operations of the company.

Grace Gebbie Drayton was a Philadelphia illustrator who first drew the Campbell Kids in 1904. The chubby and cherubic kids originally appeared in advertisements posted on streetcars. They became a staple of much of the company's print advertising campaign throughout the 20th century and are still used today. Campbell Kids dolls were first offered as a promotion in 1910 and have become popular collector's items.

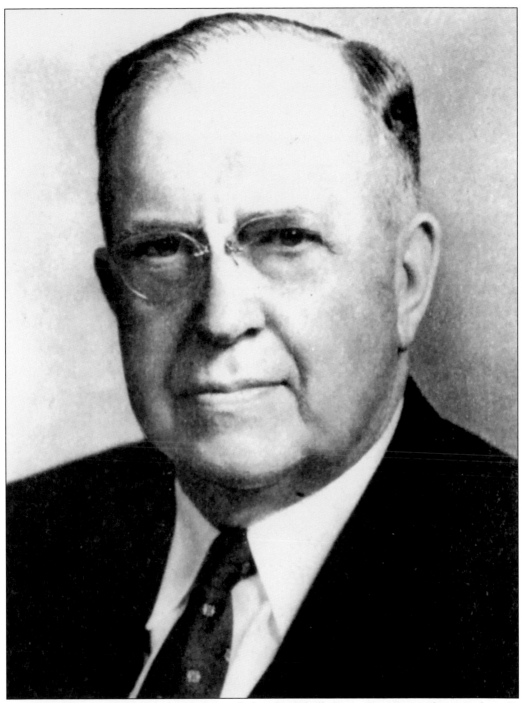

James McGowan Jr. became president of the Campbell Soup Company when Arthur C. Dorrance died in 1946. During his tenure as president, Campbell acquired V8 vegetable juice, and Campbell advertisements began airing on television. McGowan retired in 1953 and was succeeded by William Beverly Murphy. McGowan, born in 1886, died in 1961.

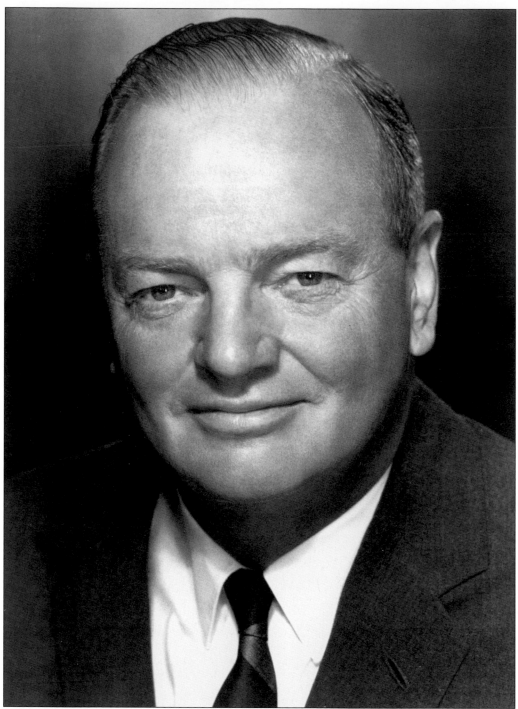

William Beverly Murphy succeeded James McGowan Jr. as president in 1953. During his presidency, Campbell Soup became a public company (1954), entered the frozen-food business with the purchase of C.A. Swanson & Sons (1955), opened its present corporate headquarters in Camden, New Jersey (1957), and purchased Pepperidge Farm and Godiva Chocolatier (1961 and 1966, respectively). In the nearly 20 years of Murphy's tenure, the company saw sales triple.

Harold A. Shaub became president of the Campbell Soup Company in 1972, when William Beverly Murphy retired. During Shaub's presidency, Vlasic Foods was acquired (1978). He retired in 1980 and was succeeded by R. Gordon McGovern.

R. Gordon McGovern was named president of the Campbell Soup Company after Harold A. Shaub retired in 1980. Prego spaghetti sauces and Campbell's Home Cookin' soups were introduced during his tenure, which ended in 1990.

David W. Johnson took over the presidency of the Campbell Soup Company in 1990. While he held the office, Campbell celebrated its 125th anniversary and introduced 19 new soups (the biggest soup roll-out in the company's history), both in 1994.

Douglas R. Conant was appointed president and chief executive officer of the Campbell Soup Company in January 2001. He is the 11th leader in the company's history. Before working for Campbell, Conant served as president of Nabisco Foods Company from 1995 to 2000. He began his career in 1976 in marketing at General Mills. He moved to Kraft in 1986, when he held management positions in marketing and strategy. He joined Nabisco in 1992 and held several high-level positions there.

Chef Charles Louis de Lisle, the company's first executive chef, was with the Campbell Soup Company for 25 years.

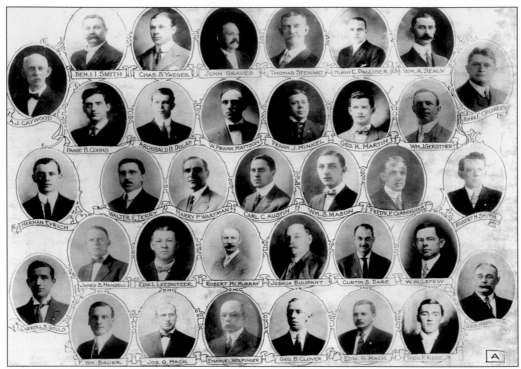

Campbell salesmen and executives are pictured in these photographs taken in the early 1900s. Despite the seemingly large sales force, Dr. John T. Dorrance relied heavily on advertising, not salesmen, to create demand for his soups. That philosophy helped Campbell became one of the most prolific advertisers of the 20th century.

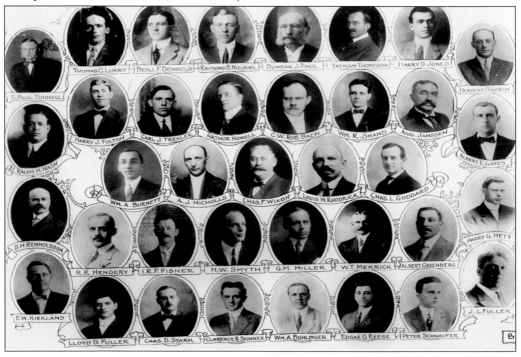

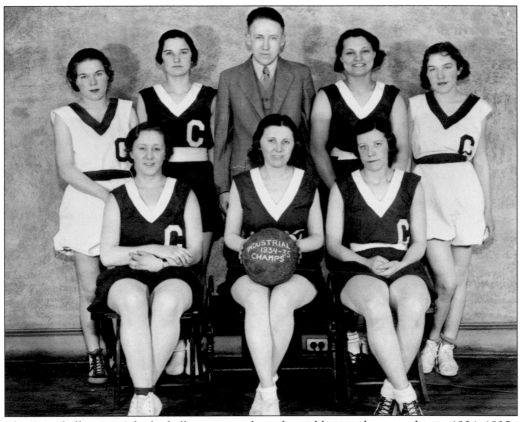

The Campbell women's basketball team won the industrial league championship in 1934–1935.

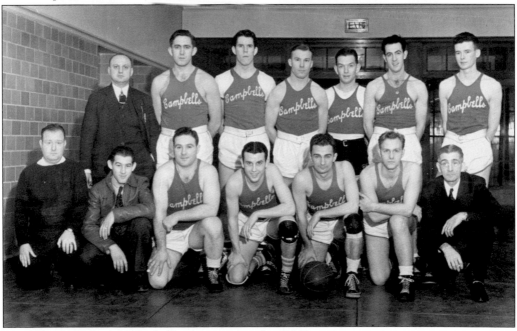

The Campbell men's basketball team is pictured in 1940.

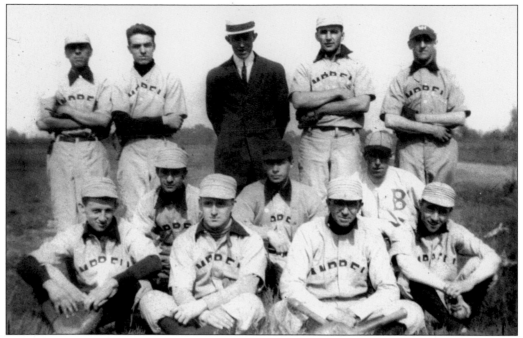

The Campbell men's baseball team poses in 1914. Today, the Camden Riversharks, established in 2001, play their home games at Campbell's Field, built on the site of the Campbell manufacturing plant along the banks of the Delaware River.

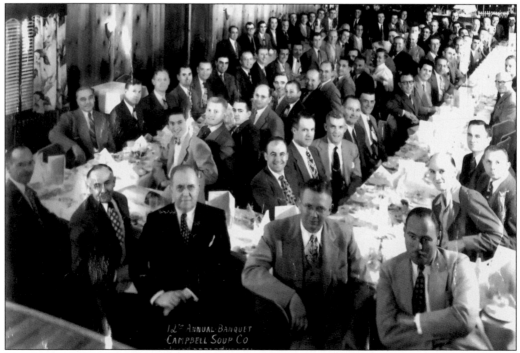

Members of the Campbell Soup Company interdepartmental bowling league are shown enjoying a meal during their 12th annual banquet in June 1949. Company president James McGowan Jr. is seated in the front row, third from the left.

Amos and Andy visited the Campbell Soup Company general offices in Camden, New Jersey, in 1949. The comedic duo had a radio show that helped promote the company's growing soup line. Amos is responsible for the name of chicken with noodles soup to be switched to chicken noodle soup. The change occurred when he misread his copy on the air in 1934, the year of the soup's introduction, and sluggish sales skyrocketed.

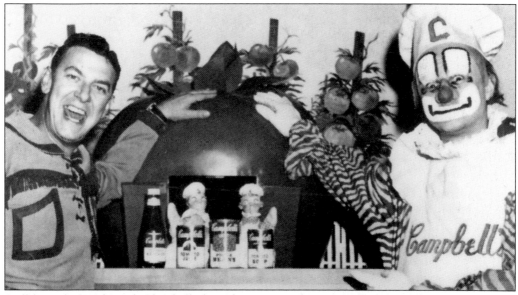

Buffalo Bob Smith and Clarabell the Clown teamed up to sell Campbell products to the mothers of young children who watched the Howdy Doody show in the 1950s. Television was a natural extension of the company's longstanding print and radio advertising campaigns. In 1954, the company earmarked about $6 million for magazines and Sunday supplements, $4.5 million for television, and about $1 million for radio.

Television star Donna Reed poses for a publicity shot on the set of her television show in the 1950s. Campbell began sponsoring the popular family program in 1958.

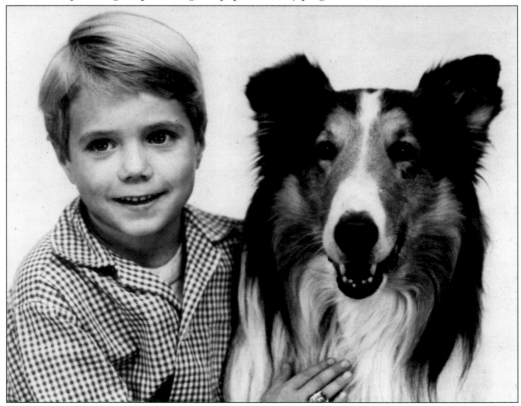

Jon Provost is seen with Lassie, America's favorite collie, in a photograph from the 1950s. Campbell started advertising on television in 1950 and began sponsoring *Lassie* in 1954.

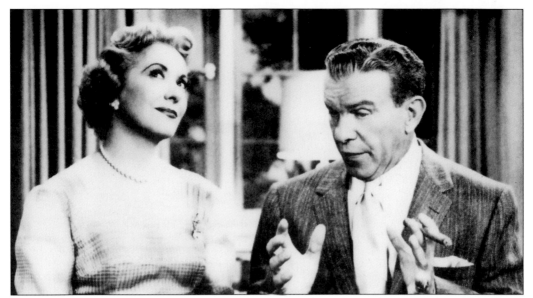

Married comedians Gracie Allen and George Burns hosted a radio program in the 1930s. Campbell began sponsoring radio programs in 1931 but discontinued the effort the next year because of disappointing results. The company resumed its radio advertising campaign in 1934 with a variety show, which was replaced with *The Burns and Allen Show* in 1935.

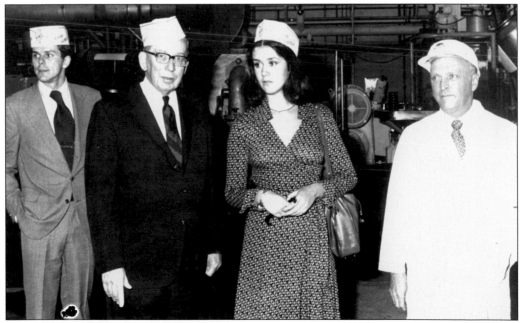

Terry Anne Meeuwsen, Miss America of 1973, is taken on a tour of the Camden facility. Dr. Carl Kreiger, the president of research and development, is second from the left. It was tradition that the newly named beauty queen visit the offices and plant soon after accepting her crown in Atlantic City, New Jersey. (Courtesy of Harry Nelson.)

This 1960 photograph shows how the Campbell Soup Company responded to devastating floods that struck Nebraska the spring of that year. The donated food was transported from the company's Chicago plant to its Omaha facility. It was then given to the American Red Cross, which distributed it to needy families. The Campbell Soup Company has long been involved in a variety of community outreach programs, including the popular Labels for Education program, which has furnished schools across the nation with needed equipment and supplies. (Courtesy of Harry Nelson.)

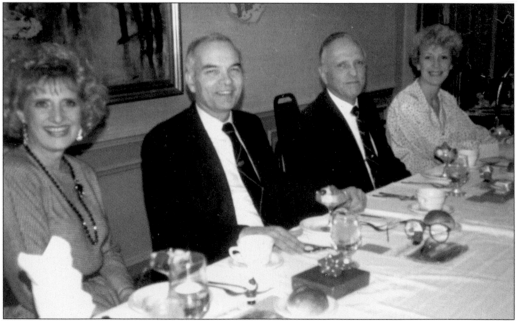

Shown at the 1987 Christmas party for Campbell Soup Company retirees are, from left to right, Anne Nelson, company president R. Gordon McGovern, former pilot plant manager Harry Nelson, and personnel representative Carol Ritchie. (Courtesy of Harry Nelson.)

Five

TO MARKET

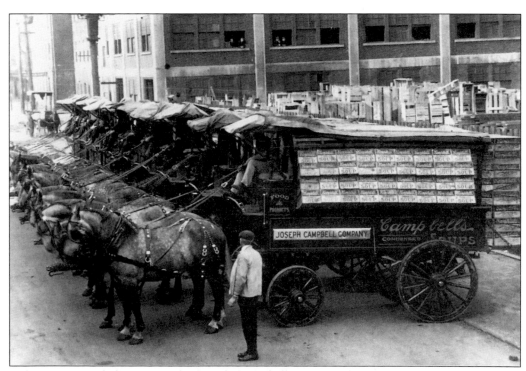

Delivery wagons belonging to the Joseph Campbell Company line up in front of the Camden, New Jersey factory where the cases of the 21 soup varieties they carried were manufactured. The company had a stable of Percherons to pull the wagons along their appointed rounds. (Courtesy of Harry Nelson.)

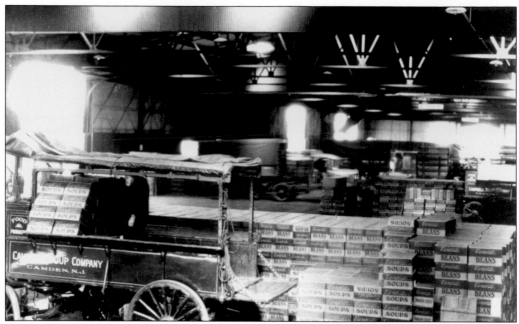

Cases of pork and beans are stacked in the warehouse in 1905. The wagon to the left was loaded with the product, which was then taken to grocery stores throughout the area.

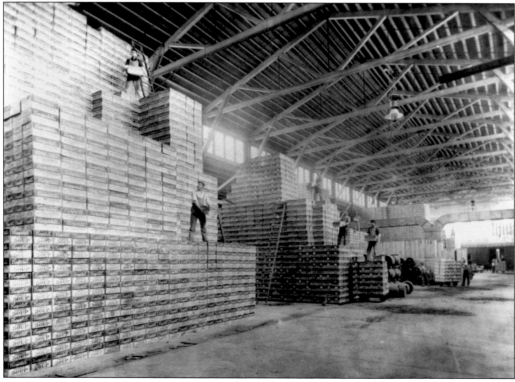

Workers place cases of soup in a section of warehouse No. 1 in Camden, New Jersey, an area covering more than 46,000 square feet. For perspective, compare the size of the stock to the men standing atop the boxes.

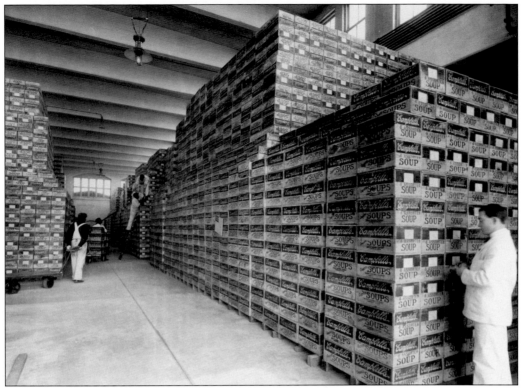

An aisle in warehouse No. 2, which covered 23,400 square feet, is inventoried in 1905. When the company's condensed soups were introduced in 1897, they were produced at the rate of 10 cases per week. By the time this photograph was taken, output had reached 40,000 cases per week.

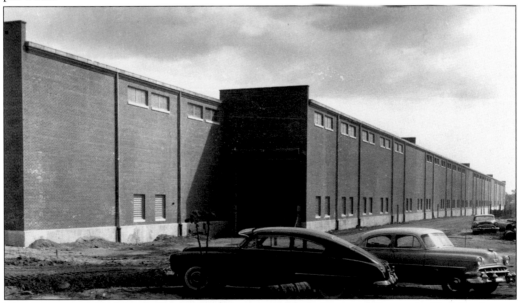

The exterior of the Campbell Soup warehouse at 36th and Lemuel Streets in Camden is seen in this 1954 photograph, complete with period automobiles.

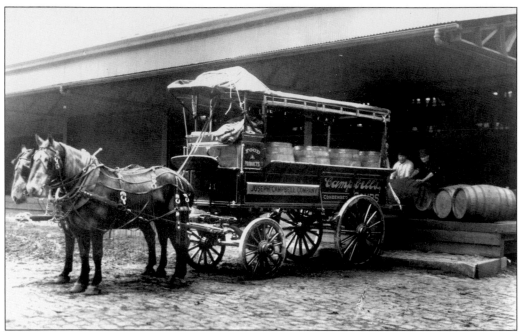

To get his product to the public, Joseph Campbell employed a fleet of horse-drawn wagons like this one, seen outside the Camden, New Jersey plant.

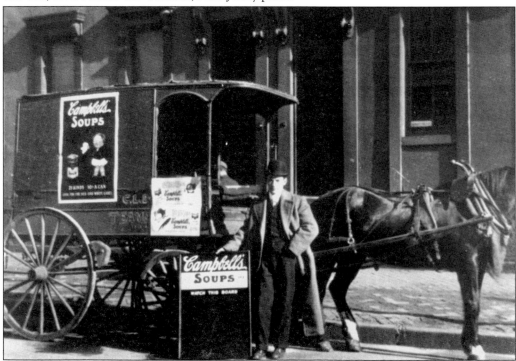

Aside from being a chemist and the father of condensed soup, Dr. John T. Dorrance was also the company's chief cheerleader. To help convince the public that his culinary creations were not only inexpensive but good quality, he took to the road, offering the samples of his original five varieties—tomato, consommé, vegetable, chicken, and oxtail.

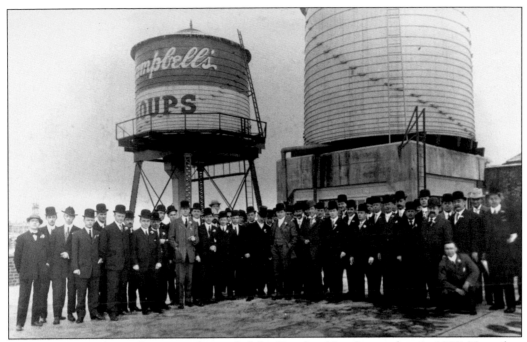

The company's sales staff poses on the roof of the Camden, New Jersey plant in 1909. Note that the water towers bearing the distinctive red-and-white colors of the soups' labels were made of wood. The three-story tanks were later replaced with steel versions that became a landmark along the Camden skyline.

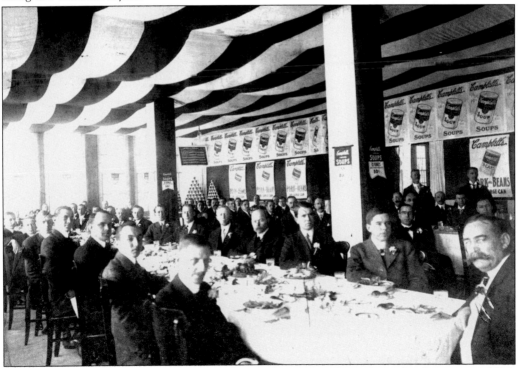

The salesmen pose for an informal portrait during a banquet at the company headquarters in 1909.

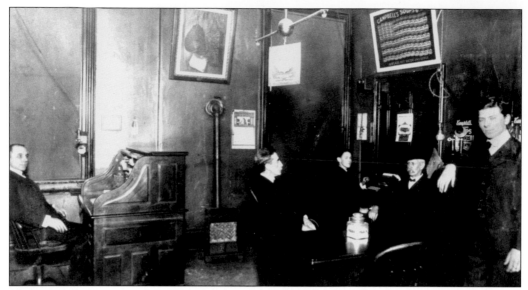

The western Pennsylvania sales office is seen in 1906. Among those pictured are William P. Caywood and Albert James Caywood (third and fourth from left, respectively). Hanging on the wall is the now familiar lithographed tin sign in which cans of the company's soup are arranged to depict an American flag.

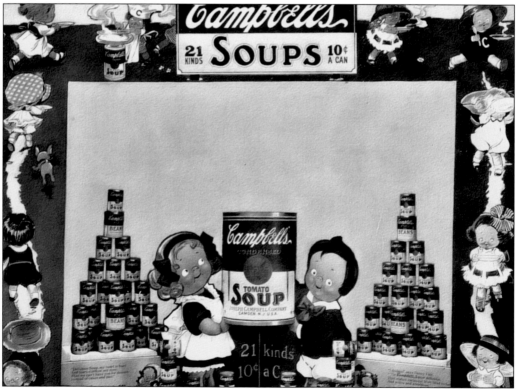

A store display from 1913 shows the cherubic Campbell Kids in a variety of poses and activities—all, of course, involving soup. Company salesmen carried pocket guides with directions for setting up this and similar layouts in grocery store windows.

A salesman stocks a grocery store display in 1945, when the company was introducing a new variety of its condensed product—cream of spinach soup.

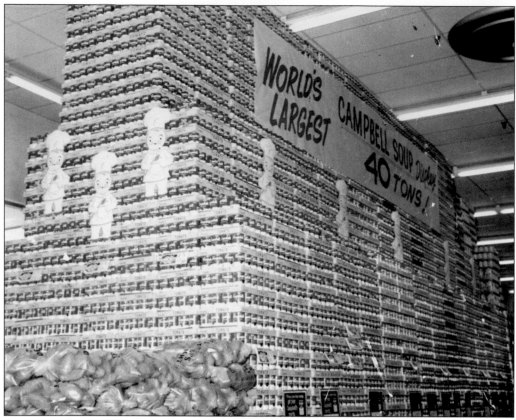

A supermarket in West Texas touted what was described as the "World's Largest Campbell's Soup Display" in 1970. Cans of soup weighing a total of 40 tons (80,000 pounds) were used to create the eye-catching arrangement.

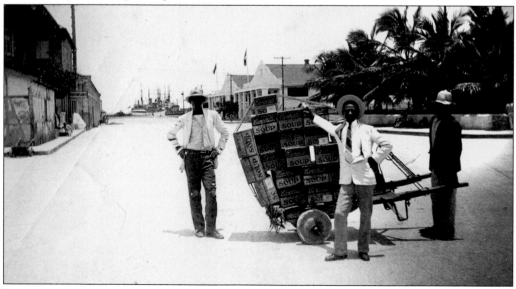

Beginning in the 1930s, the Campbell Soup Company entered international markets in which to sell its products. In Haiti, soup was delivered by an oversized hand truck.

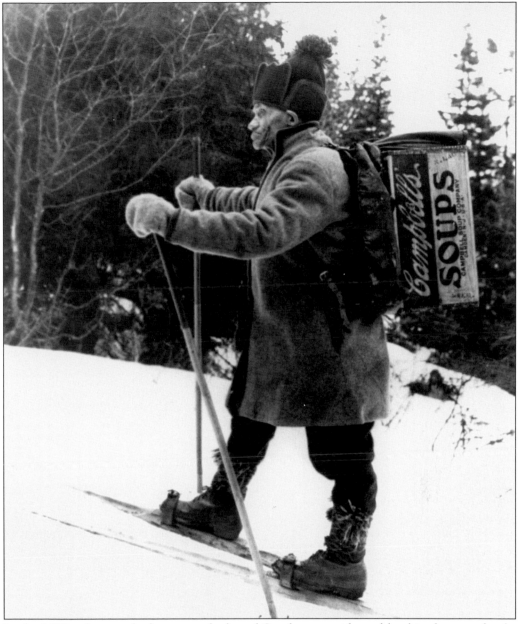

In the 1930s, the soup had even reached rural Sweden, as evidenced by this photograph of a ski-shod delivery man sent to the company by a European distributor.

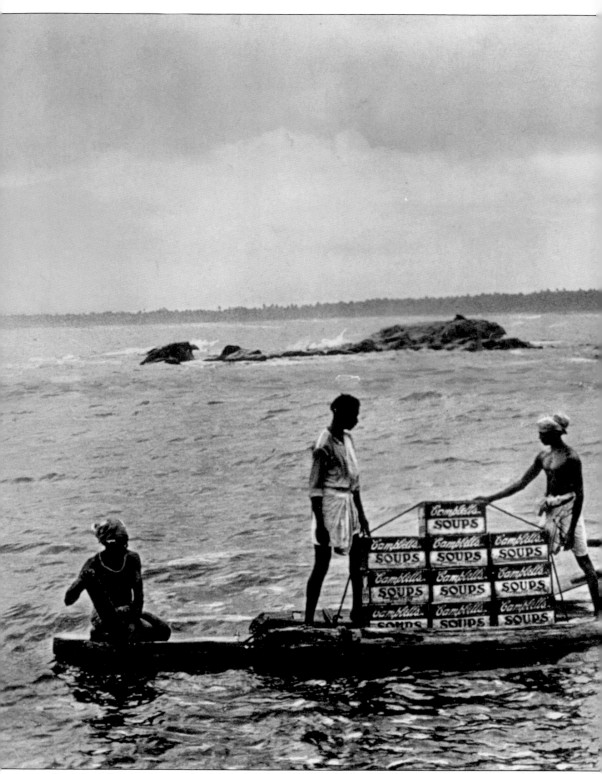

Campbell Soup takes to the water in this photograph, showing a South Seas soup delivery

under way. Today, the company's products are sold in 120 countries on five continents.

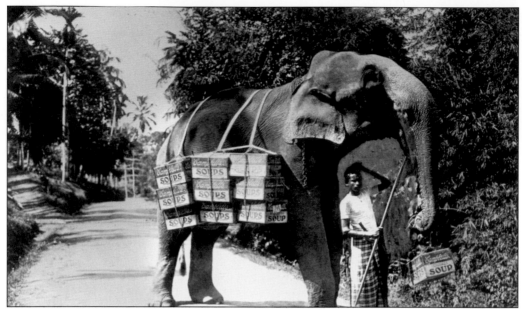

In Ceylon (now known as Sri Lanka), off the coast of India in Asia, soup was delivered thanks to a willing pachyderm.

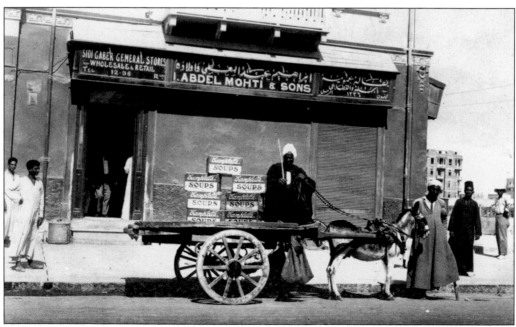

Much like their counterparts back in Camden, African salesmen in Morocco delivered cases of soup to their accounts by wagons powered by four-legged animals.

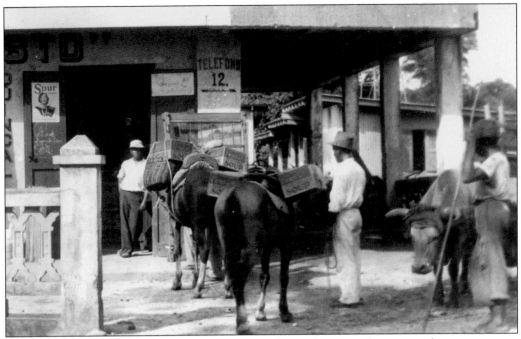

In Puerto Rico, cases of soup act as saddlebags on horses bringing them to market.

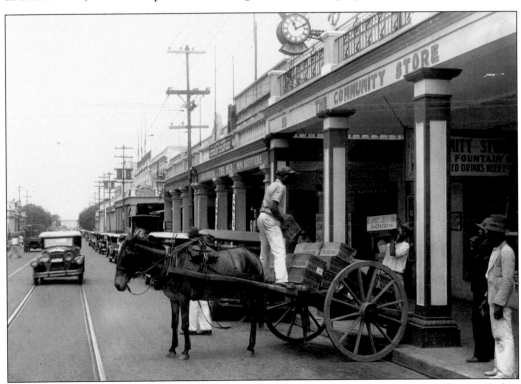

The Community Store in Kingston, Jamaica, West Indies, receives its shipment of soup. Today, the company markets regional varieties, including watercress and cream of chili poblano soup, in response to differences in cultures and tastes.

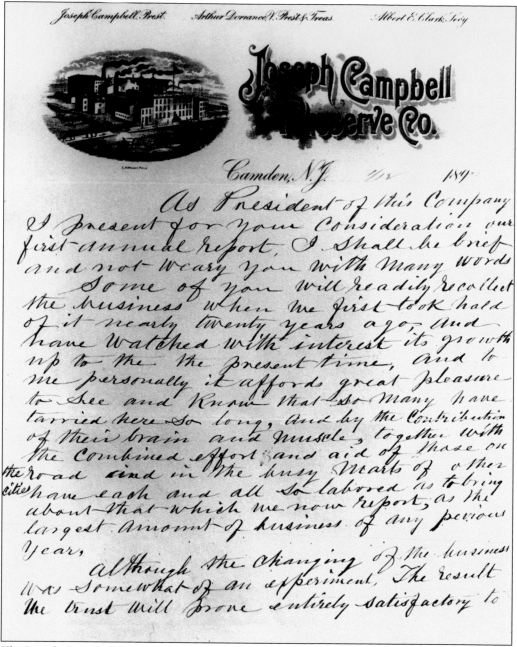

The Joseph Campbell Preserve Company's first annual report, released in 1893, was handwritten by the company president. In it, he remarks upon the company's growth and success since its 1869 founding.

Six

SELLING SOUP

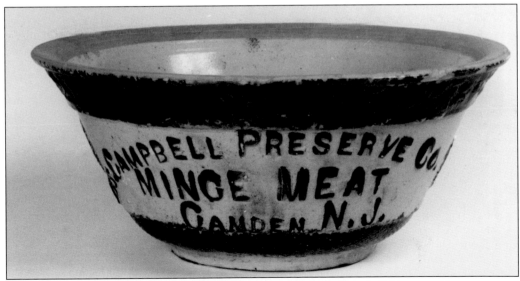

This 1890s ceramic mincemeat bowl, offered by the Joseph Campbell Preserve Company, was the first of numerous promotional products. Although mincemeat was one of the fledgling company's most popular products, it was discontinued in 1907 so the company could concentrate on what had become its core business—the production of condensed soups.

This is an early advertisement for Anderson & Campbell's hermetically sealed goods and mincemeat. The advertisement for the forerunner of the Campbell Soup Company appeared in print between 1869 and 1876.

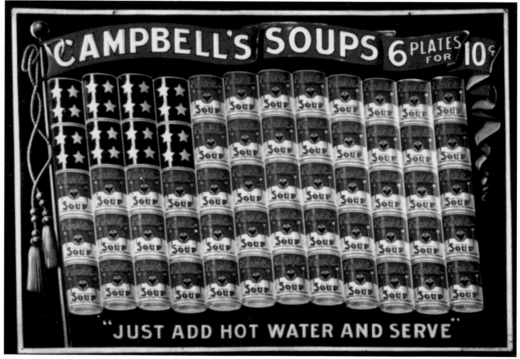

This patriotic embossed lithograph from *c.* 1902 shows the different varieties of Campbell soup, with the familiar red-and-white label laid out to form an American flag. This is a poster version of the sign, which advertised six plates of soup for 10¢ (the price of a can at that time).

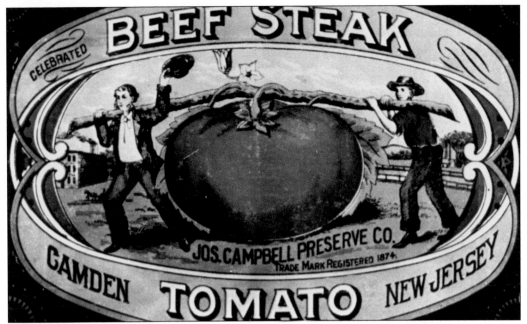

One of the best-known products of Anderson & Campbell was its beefsteak tomato. It was said that each tomato was large enough to fill a can. In 1895, the Joseph Campbell Preserve Company began marketing a ready-to-serve beefsteak tomato soup.

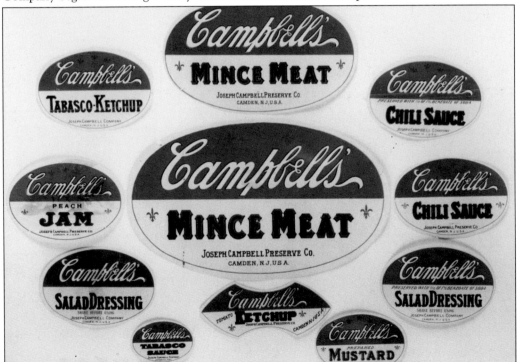

These product labels, also sporting the familiar red and white, appeared from 1892 to 1921. They show a variety of products that Campbell no longer manufactures, including peach jam, Tabasco ketchup, chili sauce, and salad dressing.

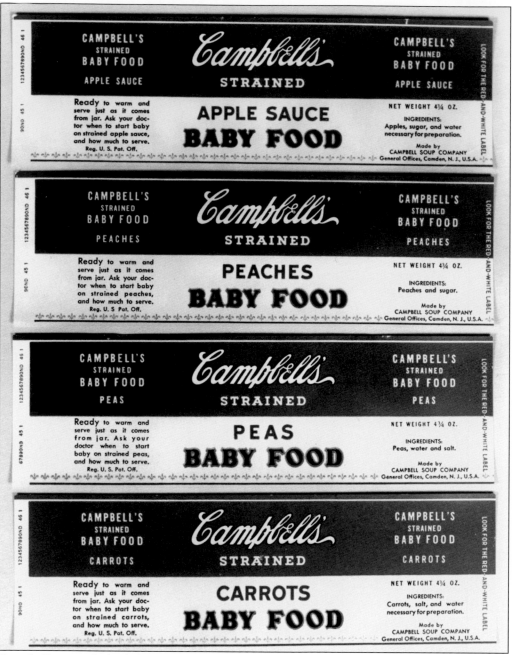

Campbell entered the baby food market in 1945 with the introduction of Campbell's Baby Soups. However, the company withdrew from the market just three years later due to a failed attempt at a merger with another baby food manufacturer and a shortage of glass jars.

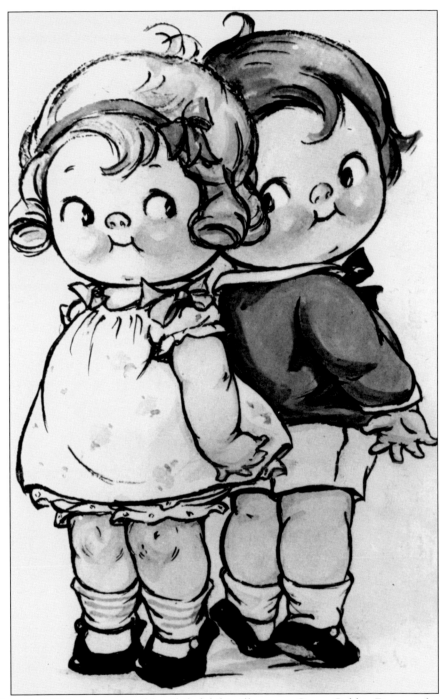

The Campbell Kids were created by Philadelphia illustrator Grace Gebbie Drayton for a series of streetcar advertisements in 1904. The cherubic, chubby-faced tykes have perhaps become the entity most identifiable with the Campbell Soup Company. Their images dominated the company's advertising campaigns through much of the 20th century. They appeared on streetcar placards, souvenir postcards, and lapel buttons and were reproduced on dolls that were popular with children in the early 20th century.

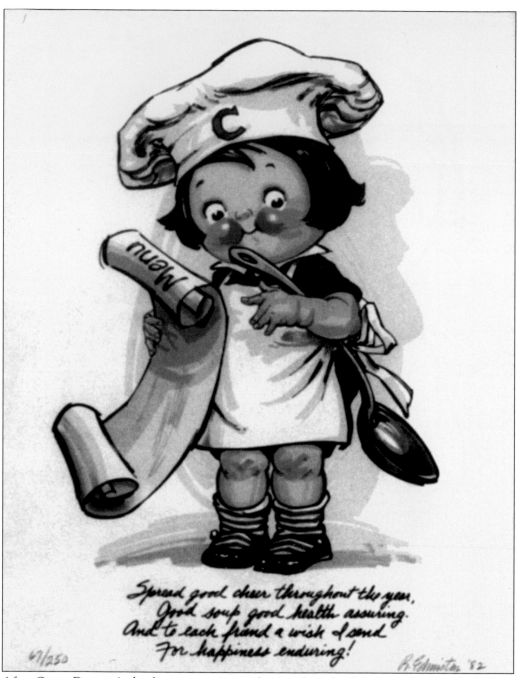

Spread good cheer throughout the year,
Good soup good health assuring.
And to each friend a wish I send
For happiness enduring!

69/250

R. Edmiston '82

After Grace Drayton's death, many artists took over the job of drawing the Campbell Kids. This 1982 serigraph reproduction, called "Good Cheer," is part of the Campbell Kid Collection drawn by Dick Edmiston. Edmiston, who studied at the Philadelphia Museum College of Art, joined Campbell Soup in 1971 as a designer and illustrator. He was mainly responsible for promotional pieces and packaging graphics. (Courtesy of Harry Nelson.)

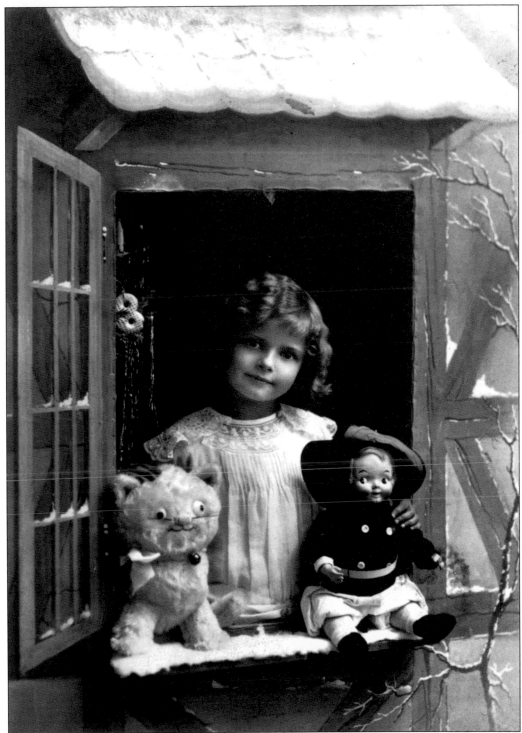

A girl is seen with one of the first Campbell Kid dolls in 1915. The doll, which is dressed as a Dutch Campbell Kid, was featured in the 1914 Sears Roebuck & Company catalog, which at the time was hugely popular among American consumers.

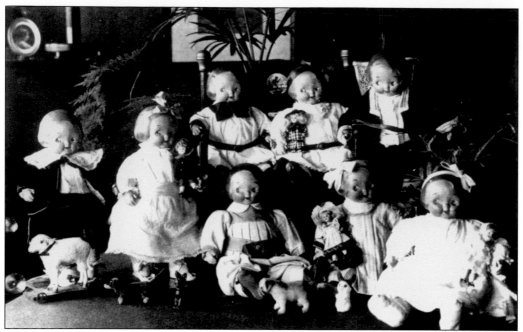

The Campbell Kids dolls were popular with American children and their parents in the early 20th century. These playthings were available between 1910 and 1916.

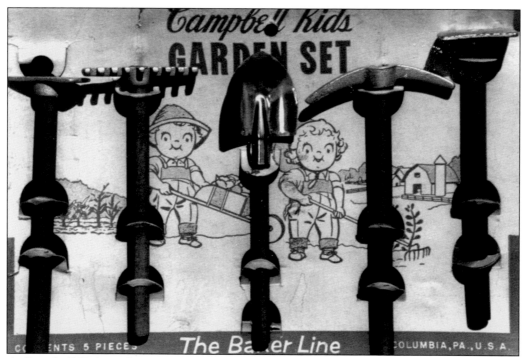

A Campbell Kids gardening set was marketed in the 1950s as a way to continue fueling the enduring popularity of the kids.

This industry advertisement, targeted at grocery store owners in the early 20th century, extols the benefits and profits that could be derived from stocking Campbell soup on store shelves.

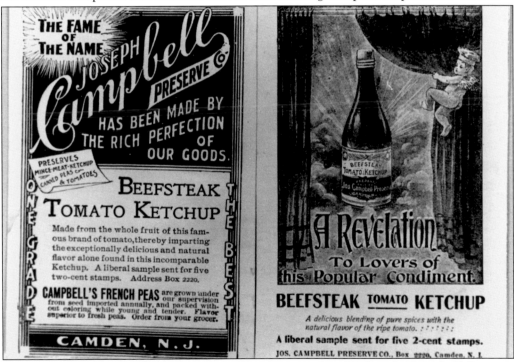

These early beefsteak tomato ketchup advertisements for the Joseph Campbell Preserve Company describe the appealing qualities of this now defunct product. As a way to increase its customer base and to boost revenue, Campbell encouraged readers to mail the company for a "liberal" sample—for only five 2¢ stamps.

Campbell's

MENU BOOK

Written by "an eminent authority on culinary topics" (Cornelia C. Bedford), this 1910 menu book listed a menu that included a variety of Campbell soup for every day of the month. The 48-page booklet featured 90 menus, the majority of which included soup.

JOS. CAMPBELL PRESERVE CO.

(Write for Illustrated Catalogue.)

EMPRESS SALAD DRESSING.

Pints, 12 to case, per case. 4 25

Half Pints, 24 to case, per case 5 00

Beefsteak Tomato Soup, 8 lb. cans 24 to case 1 75

Condensed Soup, Assorted, 1-lb. cans, 48 to ca ₩ doz..... 90

LEMON AND ORANGE PIE FILLER.

Lemon, and Orange, 30-℔ pails 06

BEEFSTEAK TOMATO KETCHUP.

Pints, 25 bottles to case, per case..... 4 00
Half-Pints, 25 bottles to case, per case........... 2 20
Pint Decanters, 24 bottles to case, per doz 2 00
Half-pint Decanters, 24 to case, per doz.......... 1 10

WORCESTER SAUCE.

Pints, 2 doz to case, per doz.....................₰1 40
Half pints, 2 dozen to case, per doz............... 75

CHILI SAUCE.

Pints, 2 dozen o case, per doz...................... 2 50
Half-pints, 2 dozen to case, per dozen............ 1 60

PRESERVES AND JAMS.

Our family 1-℔ jar, 24 to case, per doz............ 2 50
Empress Jar Jams........................... 1 65
Orange Marmalade, 24 " " 1 60
Campbell's 1 ℔ Tin Jams, 48 to case 1 00
Crescent 1 ℔ Tin Jams, 48 to case.................. 85

PURE CURRANT JELLY.

Electric Band tumblers, 24 to case, per doz 1 65
6-oz " 24 " " 1 10
5-℔ stone jars, 6 " " 14 50

Write us before buying Mince Meat.

This February 15, 1899 advertisement from *American Grocer* magazine describes many of the items the company offered at the time, including lemon and orange pie filler, beefsteak tomato ketchup, Worcestershire sauces, and preserves and jams. The advertisement also listed prices for wholesale purchases.

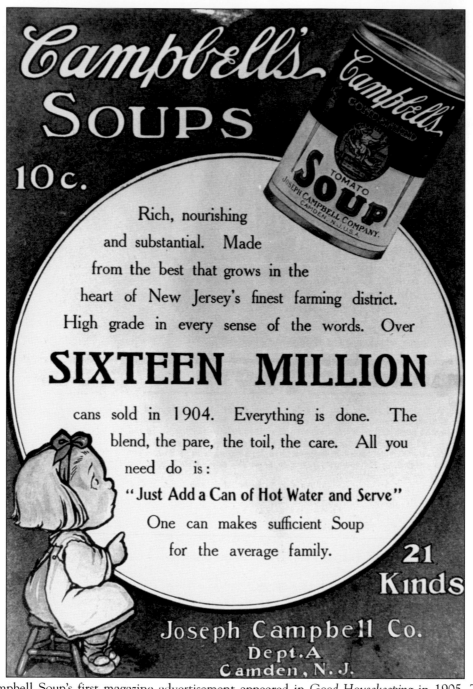

Campbell Soup's first magazine advertisement appeared in *Good Housekeeping* in 1905. The company sold 16 million cans of soup the previous year, and the advertisement speaks about how the company's 21 soups are nutritious, substantial, and produced from "the best that grows in the heart of New Jersey's finest farming district." To get the most for his advertising dollar, Dr. John T. Dorrance asked his Philadelphia advertising agency to make sure that the company's advertisement be "the first advertisement following solid text, on a right-hand page, facing a full page of text." That location became known as the "Campbell's Soup position."

118

A soup a day the modern way!

It's modern to demand the most delicious and beneficial food at the least expense of time and effort. That's why serving soup every day has become so widespread and popular. Just about everybody's doing it! It's so delicious and healthful and convenient, with 21 different Campbell's Soups for your choice—already cooked. For lunch today, select Campbell's Vegetable Soup, with its 15 vegetables —a meal in itself. 12 cents a can.

At your grocer's

My dear, you've no notion
How thrilling it feels

Asparagus	Clam Chowder	Pea
Bean	Consommé	Pepper Pot
Beef	Julienne	Printanier
Bouillon	Mock Turtle	Tomato

Campbell CONDENSED

VEGETABLE SOUP

CAMPBELL SOUP COMPANY
CAMDEN, N.J., U.S.A.

This advertisement appeared in magazines in 1918 and describes the short amount of time needed to prepare Campbell soup. With 15 vegetables, Campbell's vegetable soup was described as "a meal in itself" at a price of only 12¢ per can. (Courtesy of Harry Nelson.)

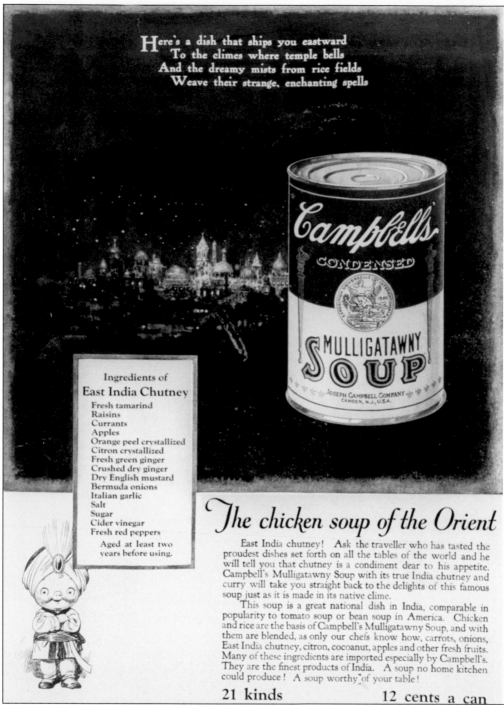

Here's a dish that ships you eastward
To the climes where temple bells
And the dreamy mists from rice fields
Weave their strange, enchanting spells

Ingredients of
East India Chutney

Fresh tamarind
Raisins
Currants
Apples
Orange peel crystallized
Citron crystallized
Fresh green ginger
Crushed dry ginger
Dry English mustard
Bermuda onions
Italian garlic
Salt
Sugar
Cider vinegar
Fresh red peppers

Aged at least two
years before using.

The chicken soup of the Orient

East India chutney! Ask the traveller who has tasted the proudest dishes set forth on all the tables of the world and he will tell you that chutney is a condiment dear to his appetite. Campbell's Mulligatawny Soup with its true India chutney and curry will take you straight back to the delights of this famous soup just as it is made in its native clime.

This soup is a great national dish in India, comparable in popularity to tomato soup or bean soup in America. Chicken and rice are the basis of Campbell's Mulligatawny Soup, and with them are blended, as only our chefs know how, carrots, onions, East India chutney, citron, cocoanut, apples and other fresh fruits. Many of these ingredients are imported especially by Campbell's. They are the finest products of India. A soup no home kitchen could produce! A soup worthy of your table!

21 kinds **12 cents a can**

Mulligatawny soup was a popular dish in India, comparable in popularity to tomato or bean soup in the United States, according to this advertisement from the 1920s. Two popular ingredients, chicken and rice, were the basis for the soup, which also included carrots, onions, East India chutney, coconut, and apples and other fresh fruit. The American palate was not prepared for the concoction, however, and the soup was discontinued in the 1930s.

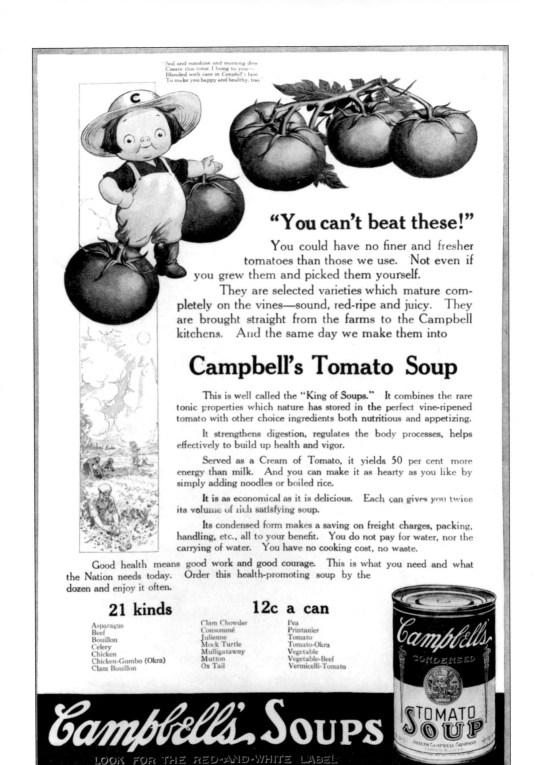

This advertisement from the 1920s extols the virtues of Campbell's tomato soup. The soup, introduced in 1897 and one of the company's most popular brands, helped many a southern New Jersey farmer earn his living by growing tomatoes.

EAT SOUP AND KEEP WELL

All set
for a good time!

THE sense of taste is especially keen in children. Their appetites are always on the hunt for lively flavor. In fact, if you give your memory a jog, you can readily re-live the days when all the world was but a stage for your appetite's adventures.

It's the wise mother who turns this to her children's own advantage by giving them food which delights and food which benefits—wholesomeness combined with that sparkling, tingling flavor which makes the child really enjoy the home meals.

Campbell's Tomato Soup is a tremendous favorite with the children. It has that bright, vivid goodness which instantly attracts them. And best of all, they can eat all of it they want, for it is as healthful as it is delicious. Let them enjoy it often, too, as Cream of Tomato, easily prepared according to the directions on the label. Every grocer has Campbell's Tomato Soup.

21 kinds to choose from...

Asparagus	Mulligatawny
Bean	Mutton
Beef	Ox Tail
Bouillon	Pea
Celery	Pepper Pot
Chicken	Printanier
Chicken-Gumbo	Tomato
Clam Chowder	Tomato-Okra
Consommé	Vegetable
Julienne	Vegetable-Beef
Mock Turtle	Vermicelli-Tomato

LOOK FOR THE RED-AND-WHITE LABEL

Yo-ho for the jolly tar,
Yo-ho for the bounding sea,
For the sun and moon
And my good soup spoon
And the Campbell's inside of me!

MEAL-PLANNING IS EASIER WITH DAILY CHOICES FROM CAMPBELL'S 21 SOUPS

A *Saturday Evening Post* advertisement from July 1932 lists the benefits that children and their mothers derive from eating (and serving) Campbell's tomato soup.

Give them Health–and the world is theirs!

The healthy child lives in a well-managed home. In planning the children's meals, the careful mother recognizes that youth must be served with a happy combination of bright and attractive foods, which are at the same time splendidly wholesome and healthful.

For the young appetite is especially keen and alert for the things that taste good. It responds instantly to such food and needs no parental persuasion. When Campbell's Tomato Soup invites with its sparkling, delicious flavor, it takes no "discipline" to make it disappear. And it fairly teems with sunny, healthful invigoration.

And what comfort it is to know that Campbell's Tomato Soup is made in kitchens of such gleaming cleanliness! Campbell's standards are world-famous for their strictness and purity. Not only the finest ingredients that money can buy, but a care and attention to every fine detail that safeguards and protects the goodness of the soup for your children.

You're always *sure*, when you serve Campbell's!

Children enjoy it either way!

It's Tomato Soup when you add water. It's Cream of Tomato when you add milk or cream. Either way, it's a hit with the youngsters.

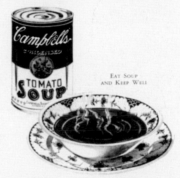

EAT SOUP
AND KEEP WELL

21 kinds to choose from...

Asparagus	Mulligatawny
Bean	Mutton
Beef	Ox Tail
Bouillon	Pea
Celery	Pepper Pot
Chicken	Printanier
Chicken-Gumbo	Tomato
Clam Chowder	Tomato-Okra
Consommé	Vegetable
Julienne	Vegetable-Beef
Mock Turtle	Vermicelli-Tomato

Tomato Soup — 2 for 15 cents
Other kinds — 10 cents a can

LOOK FOR THE RED-AND-WHITE LABEL

When danger calls,
With strength I swoop—
But don't thank me,
Thank Campbell's Soup!

Campbell's Tomato Soup

This July 1933 advertisement from the *Saturday Evening Post* describes what a healthy meal Campbell's tomato soup makes for children. "It takes no discipline to make it disappear," the advertisement states. The cheerful beach scene is a direct contrast to what was happening in America at the time—the Great Depression.

Calling all wives
(out of hot kitchens)

Now IS THE TIME for all good wives to come to the aid of—*themselves.* Let aprons be tossed aside early and nonchalantly. Let the chores indoors be the lightest of the year. Keep the home fires out. Catch up with the fun and relaxation that passed you by last winter.

You won't be slighting the family's welfare, either. Surely you've noticed that sensible women are raising the Red-and-White flag of kitchen surrender—handing over a lot of their work to Campbell's. The Campbell label (red-and-white) stands for women's rights to carefree summers.

Reaching for a can of Campbell's Soup on the pantry shelf is an everyday occurrence in the summer scene. It has become a national habit, spreading faster and wider each season. Soup is a "natural" for good summer eating. What the system needs now is bright, bracing, invigorating food . . . to take up the slack of the hot-weather let-down . . . or to renew energy after strenuous out-door exercise.

Soup—enticing, delicious soup—*Campbell's* Soup—was never more eagerly welcomed by hungry families. In preparing it, you are out of the kitchen in a wink. For many a meal you can depend mainly upon Campbell's Vegetable Soup, with its sturdy nourishment "all wrapped up" in a flavor that is most delightful.

Fifteen of the garden's best-liked and choicest vegetables are cooked in extra-rich beef stock which has been long simmered in true home style. Men go for Campbell's Vegetable Soup in a big way. And it's a match for any youngster's bounding appetite. Be sure to include it among your regular Campbell helper-outers. Remember, too, that Campbell's Soups are at your grocer's, wherever you may go!

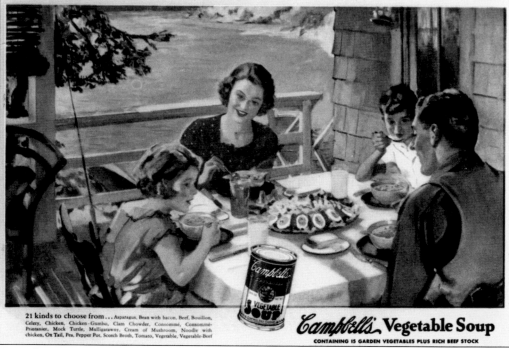

21 kinds to choose from . . . Asparagus, Bean with bacon, Beef, Bouillon, Celery, Chicken, Chicken-Gumbo, Clam Chowder, Consommé, Consommé-Printanier, Mock Turtle, Mulligatawny, Cream of Mushroom, Noodle with chicken, Ox Tail, Pea, Pepper Pot, Scotch Broth, Tomato, Vegetable, Vegetable-Beef

Campbell's **Vegetable Soup**

CONTAINING 15 GARDEN VEGETABLES PLUS RICH BEEF STOCK

As early as October 1937, housewives were looking for ways to reduce the time they spent in the kitchen and maximize the time they spent with their families. This advertisement from the *Saturday Evening Post* describes how serving Campbell's soup in the summer will help cut down meal-preparation time. The advertisement boasts, "Surely you've noticed that sensible women are raising the Red-and-White flag of kitchen surrender—handing over a lot of their work to Campbell's."

"The way we manage our food supply will have a lot to do with how soon we win this war. Food is a weapon—a most powerful weapon. And the food we consume here at home is just as much a material of war as the food we send abroad to our soldiers and fighting allies."

Claude R. Wickard

SECRETARY OF AGRICULTURE

Announcing the Rationing of Processed Foods December 27, 1942

The appearance of Secretary Wickard's picture and statements in this advertisement does not constitute an endorsement of any concern or product.

is winning
FOOD ~~WILL WIN~~ THE WAR

Soon after America entered the war, Claude R. Wickard, Secretary of Agriculture, said

"Food will win the war and write the peace."

Today the first phase of that shrewd prophecy is on its way toward becoming a reality. With Secretary Wickard as head of our national Food Administration, America's food resources are building fighting power and morale for our Allies across the seas. Also, the men of our own rapidly growing Army and Navy are getting nourishing food and getting plenty of it. And though great quantities of American foods are going to our fighting men and our Allies, it is still true here at home that we Americans have enough of the foods we need for good health. That is the way it has been planned, and that is the way it is to continue.

Yes, there is rationing. And it's true, there are shortages. But remember that America's millions of farmers, truck gardeners, ranchers, dairymen, grain millers, meat packers, canners and food retailers have determined that victory comes first and food can and will do its part toward the winning of the war.

Our country's packers of canned foods are today devoting their knowledge, ingenuity and equipment to the vital task of packing America's foods so that their flavor and nourishment may be carried to our fighting men on all the fronts around the world.

Along with many other American food canners, Campbell's are proud to be making flavorful and sturdy army field rations—substantial meat-and-vegetable canned foods that our soldiers and marines carry with them into combat areas.

Army field rations for our fighting men are being prepared at the rate of many, many millions of cans per month. So if there are times when your favorite canned food is not available, remember your loss may mean some fighting man's gain. It means that he is getting the fortifying food it takes to win in battle.

This job comes first at Campbell's now. But for the home front there will still be a supply of Campbell's Soups. Not as much of these soups is being packed, and you may not be able to serve them quite as often as you would wish. But when you do serve Campbell's Soups today, you will be pleased that they are made to new and improved recipes . . . hearty, delicious soups, extra-rich, extra-nourishing for the hard-working people of a nation at war.

CAMPBELL SOUP COMPANY
MAKERS OF FOODS FOR VICTORY

This *Saturday Evening Post* advertisement from April 1943 shows Department of Agriculture Secretary Claude R. Wickard in a morale-boosting role. During World War II, the Campbell Soup Company provided army field rations for fighting troops. The advertisement further describes how production of rations was the company's first priority and that there might be a shortage of regular Campbell's soups as a result.

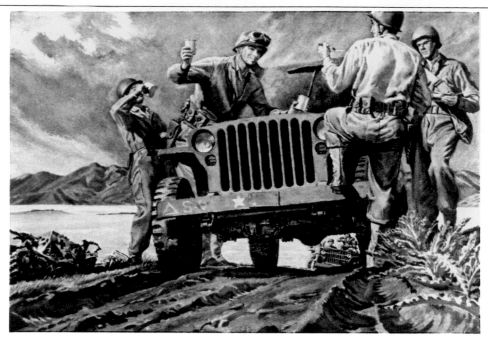

Many a soldier on field duty tucks his can of army rations under the motor hood of his jeep. When mealtime rolls around, there is his chow, warm and ready for roadside eating.

HOW TO PULL A HOT DINNER OUT OF A JEEP

IT'S JUST ANOTHER example of good old American ingenuity. But it enables the men of our Armed Forces, even when many miles from their base, to eat good American food, cooked the way a man enjoys it.

Packers of canned foods are playing a vital part in the feeding of our overseas men. The makers of Campbell's Soups, for instance, devote an important part of their production to the making and canning of balanced meat-and-vegetable dishes, developed by Army Quartermaster experts, for far-off battlefront eating. Millions of cans of these field rations are made in Campbell's kitchens . . . a part of the all-important job of keeping a great army well nourished at all times.

Our war-busy people on the home front, too, need the sort of meals that keep folks going. A family lunch or supper built around Campbell's Soup is a meal that's satisfying in deep, full flavor and in good, hearty nourishment. And, easy to fix, these soups fit well into the planning of wartime meals.

The makers of Campbell's Soups are proud to do their part, along with others of the canning industry, in feeding our fighting men as well as their families at home.

* * *

Army field rations, cooked in the U.S.A., go to our fighting men packed in cans. So if tin cans are collected in your locality, salvage every can you open. Fold in both ends, remove label, wash and flatten. Tin is vital to the war'

CAMPBELL SOUP COMPANY

MAKERS OF FOODS FOR VICTORY

This September 1943 advertisement from the *Saturday Evening Post* shows four army soldiers enjoying their Campbell's soup rations, which they heated by putting them under the hood of a Jeep. The advertisement advised civilians to collect tin cans, which would be recycled for the war effort.

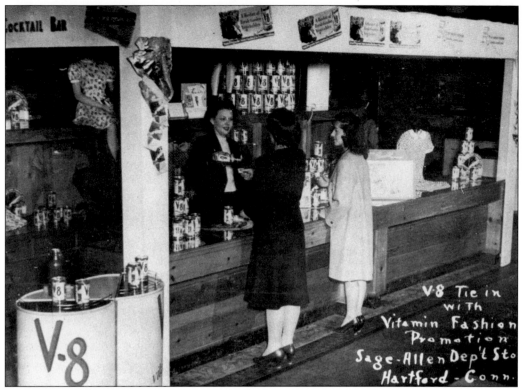

At the Sage-Allen department store in Hartford, Connecticut, in 1944, V8 vegetable juice was tied into a fashion promotion.

After cans that held tomato paste were opened, cleaned, and flattened at the Campbell Soup facility in Terre Haute, Indiana, they were shipped to Japan, where they were turned into children's toy cars. They were then exported to the United States, where they were sold. (Courtesy of Harry Nelson.)

This billboard for Campbell's tomato ketchup (lower right) appeared at Broadway and 43rd Street in New York in 1951–1952. The Times Square location offered maximum daily exposure for the product.

Every employee who worked for the company had to wear a button identifying him or her by a number, in an early version of an employee identification badge. The letter T printed in the center of this button from 1939 indicates that the wearer was a temporary worker, hired for the tomato season. (Courtesy of Harry Nelson.)